COLLAGE

JOSEPHINE LOM

COLLAGE

*With over 300 black-and-white illustrations
and 8 pages of colour plates*

DAVID & CHARLES
NEWTON ABBOT LONDON VANCOUVER
ARCO PUBLISHING COMPANY, INC.
NEW YORK

This edition first published in 1975
in Great Britain by
David & Charles (Holdings) Limited,
Newton Abbot, Devon,
in the USA by
Arco Publishing Company, Inc.,
219 Park Avenue South,
New York, NY 10003

ISBN 0 7153 6196 1 (Great Britain)
Arco Order No. 3664

© Josephine Lom 1975

Library of Congress Catalog Card Number
74-25009

Published in Canada by Douglas David &
Charles Limited, 132 Philip Avenue,
North Vancouver BC

Printed photolitho in Great Britain
by Ebenezer Baylis & Son Limited,
The Trinity Press, Worcester, and London

CONTENTS

ACKNOWLEDGEMENTS

I would like to thank the many artists and friends who kindly donated photographs or allowed their work to be photographed for inclusion in the book; the museums who allowed access to their exhibits; and the educational institutions who encouraged experimentation in the processes described.

Individual acknowledgement is given where appropriate throughout the book.

I should especially like to thank the governors, the Principal Sister D. Bell, colleagues and students of Digby Stuart College of Education, London, who in many ways made the writing of this book possible.

Finally I should like to thank my daughter Eva for her support during writing and help with the script.

Sources of inspiration photographed by the author; drawings by the author.

Processes in collage-making photographed by George Casey.

INTRODUCTION

Collages may be anything from wall-hangings and posters to decorative lids. Collage is an umbrella term for an assemblage of diverse components and these may be of any origin – animal, such as chicken bones (see page 18); vegetable, such as a loofah (see page 8); or mineral, such as copper wire (see page 10). Some may be used in their natural state, for example the seeds (see page 65); others may be adapted to suit the collage, such as the printed background (see page 46).

Collages are made for a variety of reasons. There may be the wish to decorate, expressed in the shiny foil collage (see page 12); there may be the desire to convey a slogan (see page 46); or to revive some memory, like the dunes of the Sahara (see page 62).

This book of collage 'recipes' is an introduction to the scope of the connected activities of selecting the inspiration, collecting the components and applying the methods. Simple ways of securing the components together, such as gluing, are included together with the less obvious ones of fusing and sewing. Also, less familiar processes, such as 'dribbling', 'tearing', 'dissolving', 'singeing' and 'floating' are described. These are more than just a means to achieve a desired effect. They bear a close relationship to the forces which produced the inspiration. Thus the erosion of a water-hole (see page 21) is represented by tearing strips of damp tissue; the interaction of air-currents (see 'Whisper', page 34) and water-currents by 'floating'. 'Dribbling' could epitomise creeping bacterial growth (see page 32).

Examples of collages from folklore, such as silhouettes and Victorian valentines, and Polish 'Wycinanki' (paper cut-outs), are included for more than sentimental reasons. Like the contemporary artefacts in the book, they may serve as inspirations for making collages.

I hope that the collages described in this book will appeal to a wide variety of people. Perhaps the mechanic would like to make the gasket collage, the cook the crumpet collage, the lover the valentine, the sentimental mother the photograph collage, the engineer the air-thrust print, the surgeon the heart collage and the biologist the fungus collage; or perhaps even our everyday activities and experiences may be seen in a different light – as inspiration for collage.

J. L.

MISCELLANEOUS COLLAGES

FIVE SLICES OF LOOFAH

(LUFFA AEGYPTIACA)

DESCRIPTION

15in × 19in

Five slices of a loofah, of diminishing size, embedded in holes made in a loosely woven fabric. All the components are of the same colour.

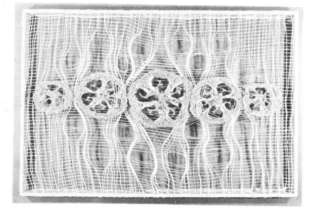

METHOD

Stretch a loosely woven carrot bag and staple on to a wooden frame. Push the taut, coarse threads aside with the fingers to form cavities in the weave and fill these holes with the slices of loofah so that the edges of the slices adhere to the circumference of the holes.

MATERIALS

Loofah
Wooden frame,
 15in × 19in

Strong glue
Ruler for measuring the
 centre of collage

Carrot bag (from the
 greengrocer)
Dye
Drawing-pins
Sellotape
Stapler and staples
Scissors

Breadboard
Knife
Yoghurt carton or jar
 for paints
Brush
Newspapers to cover
 painting area

STEP-BY-STEP

Preparation

1 Slice the loofah on the breadboard, and select five slices of diminishing size.

2 Dissolve the dye in a container and stain loofah, frame and fabric.

Mounting the Fabric

1 Lay the carrot bag on the table and place the frame on its centre, ensuring that the warp and weft are parallel to the edges of the frame.

2 Sellotape the fabric round the frame and 2in from edges to prevent the fabric fraying.

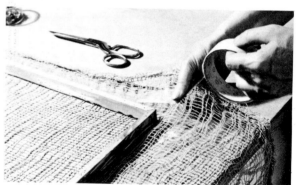

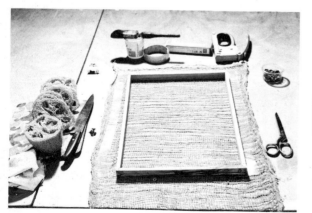

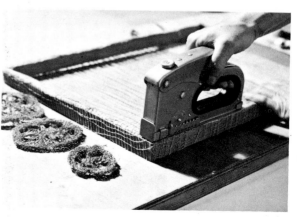

3 Trim the surplus fabric along the edges of the sellotape.

4 Fold the 2in margin under and staple it to the frame, making sure the fabric is well stretched.

Shaping

1 Place the largest slice of the loofah on the table.

2 Mark the centre of the stretched fabric and place this central point above the slice.

3 Gently but firmly push the fingers of both hands through the gaps in the weave and widen the hole to correspond to the size of the largest slice underneath.

4 Repeat this process with the other slices, after positioning them under the fabric.

Gluing

1 Apply the glue directly from the tube to the edge of the slice (on the reverse side of the slice).

2 Turn the slice over and place the glued edge on to the corresponding hole so that the edges of the hole and slice touch.

3 Hold the left hand underneath the fabric and slice; apply pressure with the right hand on top of the slice.

Finishing

When the glue is dry, finish by stretching further holes in the fabric around the slices as illustrated.

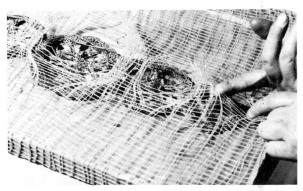

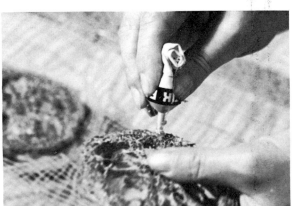

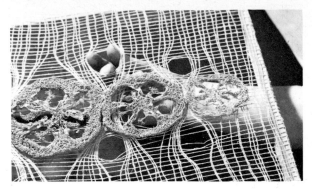

EXAMPLES

'Bubbles'. The surface of washing-up water as inspiration for experimental fibre structure

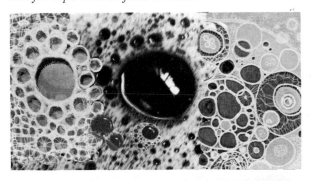

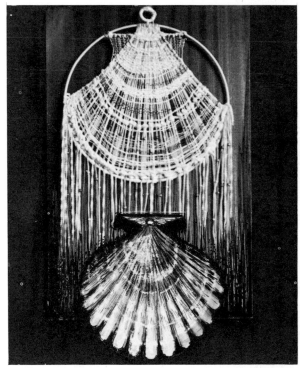

'Shell', hanging by Pauline Godfrey, Digby Stuart College of Education, London

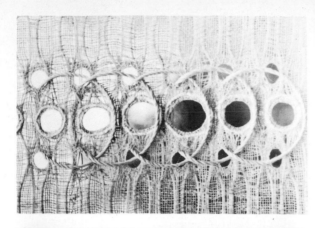

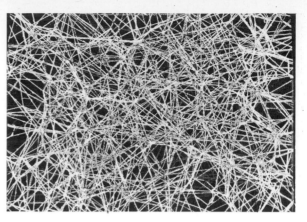

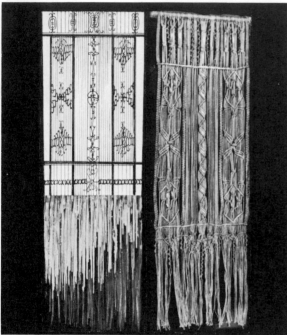

'Society'

'Copper-wire Construction' by Rod North

Macramé wall-hanging by Marianne Olsen, Digby Stuart College. Photograph by Ann Knox. Inspired by eighteenth-century English wrought-iron gate from the Victoria & Albert Museum, London

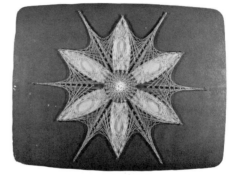

'Webbing' by Hanka Pollack. Inspired by 'Dry Rot' (Courtesy of Pescon Limited)

'Design in Thread' by Jane Murphy

DRIED CITRUS-PEEL COLLAGE

DESCRIPTION
18in × 12in

Inspired by a wasp-stung twig and diseased elm at Wimbledon Common.

Curling and twisting rosettes of dried peel, with black beads at centre, form flowers on orange hessian background. Dried leaves and raffia complete.

METHOD
Peel oranges and grapefruits to give star-shaped pieces and dry in an oven until hard. Glue previously pressed leaves to the orange base and then stitch the brittle stars on top with raffia. Stitch black beads in the centre of the rosettes and accentuate the stem with raffia.

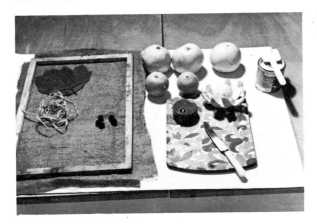

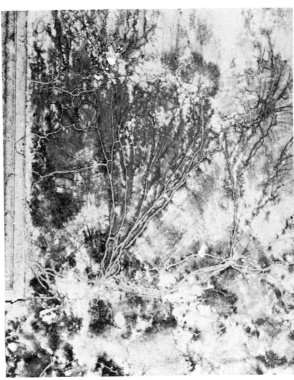

MATERIALS

3 oranges	Raffia
3 grapefruits	Black beads
Sharp fruit knife	Thick needle with large
Cutting board	eye
Oven	Glue
Frame covered with	Previously pressed and
orange hessian	dried leaves
(see page 101)	Scissors

STEP-BY-STEP

Preparation

1 Peel three grapefruits and three small oranges so that complete, star-shaped pieces are formed. Slash the skin longitudinally, but not right to the base of the fruit, which remains uncut to hold the 'petals' together. Gently ease out the naked fruit, so as not to tear the peel, which is then pressed flat with the hands.

2 Cut additional slashes to form narrower petals.

3 Gently make a hole in the centre of the star.

4 Place the peels in a warm oven (eg 175°F) for about five hours, or until completely dry and hard. (Alternatively they may be dried at room temperature, but this takes several days.)

5 Remove the now curled and twisted rosettes from the oven, ready for use.

Mounting

1 Select previously pressed and dried leaves and glue them on to the base in appropriate positions.

2 Cut a suitable length of raffia, split it if it is too thick, thread it on to a needle and tie a knot at one end. Thread the raffia from the underside to the right side of the base in the place where the centre of the flower is to be.

3 First thread the large grapefruit-peel, through its centre curls underneath, on to the raffia. Then thread the smaller orange-peel, through its centre, curls uppermost. Finally thread the black bead.

4 Gently pull the raffia and ease the peels and beads down to the base.

5 Stitch the raffia back through the centres of the peels to the underside and pull it carefully to secure the flower.

6 Repeat the process to form the other flowers, varying the sizes of the peels and combinations of peel to form different flowers.

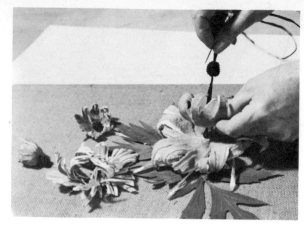

7 Complete the collage by stitching in the stems with raffia, if desired.

8 Secure the ends of the raffia with knots or by sewing small beads to the underside with the loose ends. Alternatively, the peel and beads may be glued on to the base.

FOIL COLLAGE

DESCRIPTION
18in × 12in
Inspired by a geometrical pattern.
Resembles a piece of crumpled metal embossed with geometrical, coloured pattern.

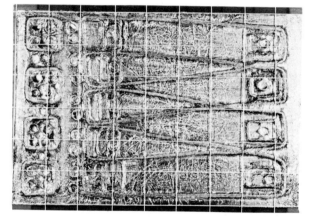

METHOD
After appropriate preparation, bend string into various shapes and glue on to the base, which is then covered with tinfoil and finally rubbed with coloured inks or crayons.

MATERIALS
Geometrical pattern
Chipboard or wooden board
String
Roll of kitchen foil
Coloured inks or crayons
Brine
Newspapers to protect working area
Clean rag
Gloves

Rubber cement as adhesive, together with applicator and solvent for the cement
Blocks – square boxes or wooden blocks for right-angled shapes; pens or cylinders for rounded shapes
A container in which to soak the strings

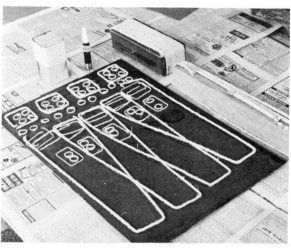

Preparation

1 Soak the strings in brine overnight.
2 Decide on the pattern and on the shapes necessary.
3 Select the blocks or solid shapes on which the strings will be wound.
4 Wind the damp strings on to these blocks and tuck in the ends neatly.
5 When sufficiently dry, cut the bent string into the desired shapes.

Application

Paste the board and place the strings in position on the sticky surface to form the desired pattern. Cover the board carefully with paper and press the collage under heavy books to dry, making sure that the paper does not also stick to the board.

Covering

1 Unroll the tinfoil, right side face downwards.
2 Place the board with the strings on to the foil.
3 Measure the size of foil required by allowing a 2in margin round the board. Cut the foil to this size.
4 Remove the board and crumple the foil into a ball.
5 Gently unfold the ball and again place the crumpled foil face downwards on to the table.
6 Apply adhesive to the wrong side of the foil.
7 Place the board, strings downwards, centrally on to the sticky surface of the foil.
8 Leave the edges of the foil projecting over the board; rub the right side of the foil (now stuck on to the board) gently with a clean rag to produce an embossed effect. Start from the centre outwards, to exclude the air.
9 Tuck the projecting edges of the foil around the board and glue them in place.

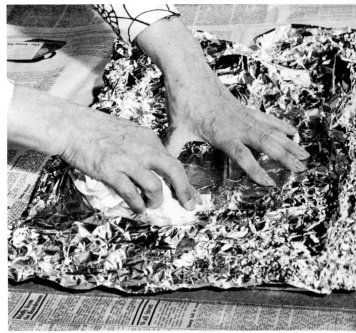

Colouring

There are several alternatives:

 (a) Treat the surface with one application of waterproof black ink for an antique silver effect.
 (b) Paint the surface with waterproof coloured inks for an iridescent appearance.
 In methods (a) and (b) the surface is mopped gently when the ink is still wet, leaving the ink where desired (eg, in the crevices).
 (c) Rub the surface with coloured crayons.
 (d) Stick pearls on to the surface.
A combination of any of these may be used. In the collage described, only method (c) was used; in the collage entitled 'Surf', the strings were applied in coils, then methods (a) and (d) were combined.

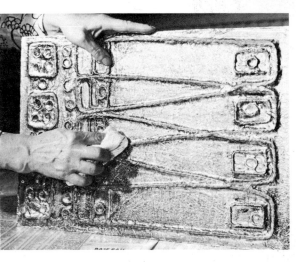

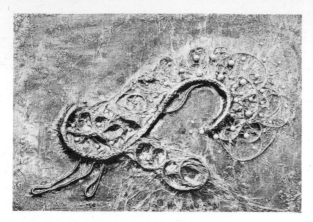

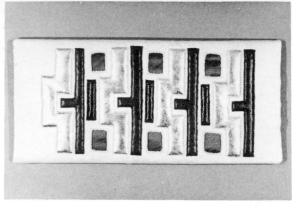

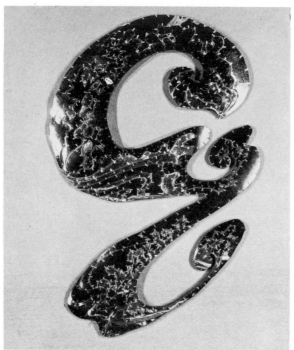

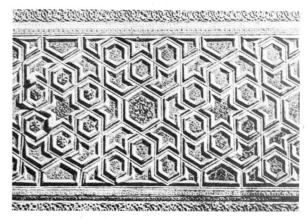

PAPIER-MÂCHÉ LIDS AND PLAQUES

LIDS

DESCRIPTION

Inspired by bronze shield of the first century BC or AD found under the Thames (reproduced (*right*) by courtesy of Victoria & Albert Museum).

Lid A: Green and silver lid with raised circular ridges dotted with green paint, glass 'jewels' in hollows.

Lid B: Copper-coloured lid with buttons and curtain rings stuck on, and nails projecting from raised circular ridge.

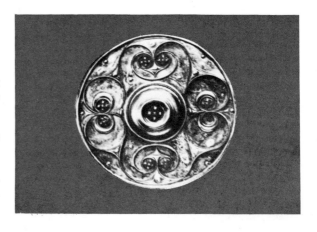

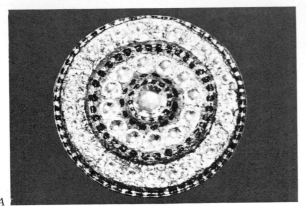

A

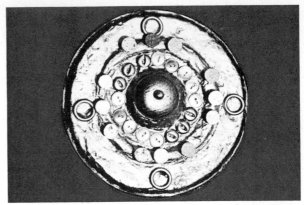

B

METHOD

Model papier-mâché on to lids previously covered with glued tissue paper, and then decorate the dried lids with foil, buttons, wires, curtain rings, beads and paint as desired.

MATERIALS

The papier-mâché:

Newspapers	Oil of clover
Bowl	Rolling pin
Wallpaper paste *or* make up from table-spoon flour mixed with cold water into a thick paste, and $\frac{1}{2}$ pt boiling water added	Rags
	Newspaper, to protect working area
	Oven, if rapid drying is required

The decoration:

Various curtain rings, beads, nails, buttons	Vitrina inks, brush and solvent
Tin or aluminium foil	Copper-paint spray

Other requirements:

2 tin lids, eg from coffee tins	Drill or tin opener (if lid is to hang)
Tissue paper	Metal rings (as guides)
Glue and brush	Sandpaper

STEP-BY-STEP

Making the papier-mâché

1 Place paste into bowl and add brine until a solution the consistency of thin soup is formed. Then add a drop of oil of clover to preserve the mâché.

2 Tear newspapers into small pieces and soak them in the bowl overnight.

3 The next day, squeeze out excess water from the soaked paper and turn it into a pulp by squashing the

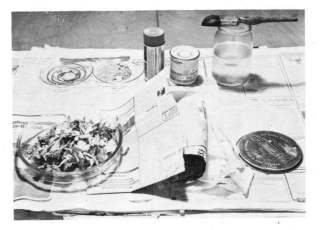

pieces between rags or newspapers with a rolling pin.

4 The moist pulp is now ready for modelling.

Covering the lids

1 If the lid is to hang, pierce a hole in it.

2 Make a foundation so that the pulp adheres to the lid – tear strips from the sheets of tissue and glue them on to the lid.

3 Continue to glue successive layers until a firm foundation is formed.

4 Model the mâché pulp on to the foundation and into the shape required. Press metal rings into the pulp as guides. Raise rings of pulp, concentric with the circumference of the lid, using metal rings as guides.

5 Make indentations in the moist pulp where beads, etc are to be stuck.

6 Lift the rings.

Drying

1 If rapid drying is required, place the lid in a warm oven (eg 175° F) to dry into a hard mass. Otherwise, leave it for a few days to harden slowly.

2 Sandpaper the surface slightly to smooth it.

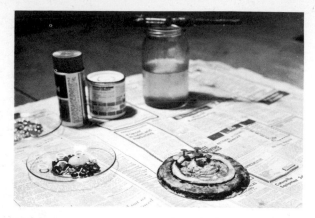

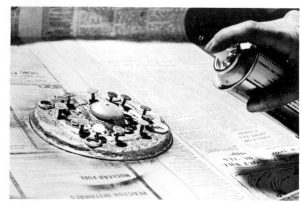

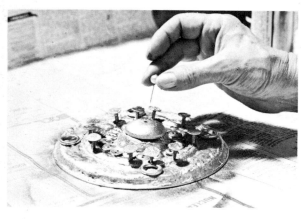

and stick it to the lid in the indentations made for it.
6 Paint the lid further as desired.

Lid B:

1 Apply glue to the indentations, and stick nails into them.
2 Apply spots of glue to the central indentations and stick buttons to them.
3 Apply glue to the curtain rings and stick them in an outer ring to the lid.
4 Glue the underside of the large, central button and stick it to the middle of the lid.
5 Place the lid on newspapers and raise and fold the edges of the paper to make a trough which will confine the spray of paint.
6 Spray the complete lid with copper paint.
7 When dry, thread a bead on to a pin and stick the pin through a hole in the central button to finish off.

PLAQUES

DESCRIPTION

Plaque A: The rough copper background has an arrangement of shells mounted on it.

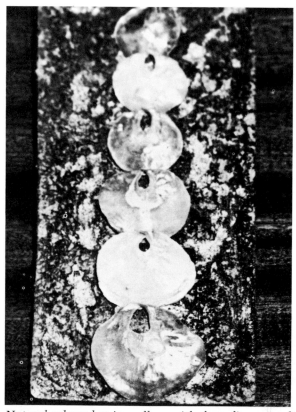

Natural-coloured string collage with three-dimensional wavy effect, inspired by sand-dunes in the Sahara desert

Decorating

Lid A:

1 Cut out a piece of foil to fit over the lid, allowing ample margin for overlap.
2 Crumple the foil into a ball and then carefully unfold again.
3 Apply glue to the lid and cover with foil, moulding it into the contours and indentations of the dried mâché. Trim the foil.
4 Paint the foil with Vitrina inks.
5 Add a spot of glue to the underside of each bead

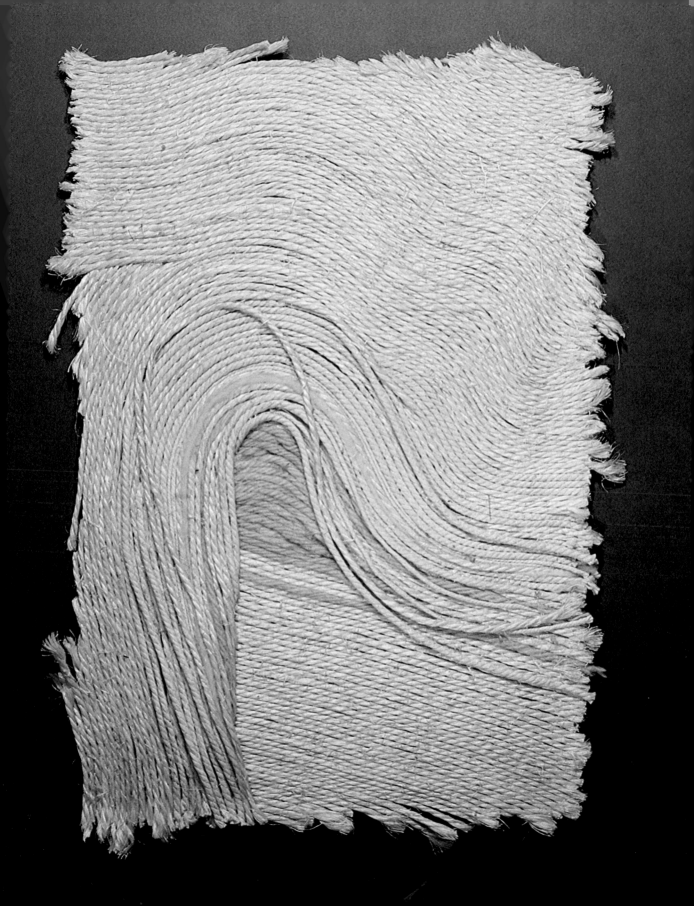

'Panel' by Jadwiga Lukawska, Łowicz, Poland

'Elisar'. Silk noil and woollen sliver

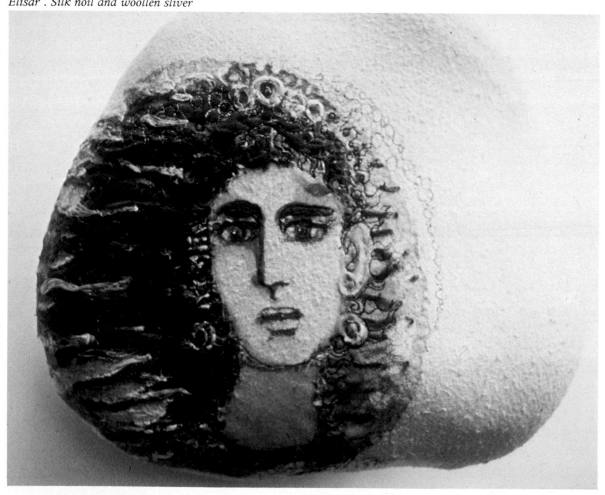

Plaque B: Inspired by the Capucine Chapel, Rome. Singed chicken bones are arranged on a grey base.

METHOD

Press alternately papier-mâché strips and pulp into a tray and leave to dry to form an oblong plaque.

Plaque A: The oblong is sprayed with copper paint, sandpapered to produce uneven coverage and then shells are glued on to it in the desired pattern.

Plaque B: The plaque is sandpapered and then cleaned and singed chicken bones are glued on to it.

MATERIALS

The papier-mâché:
As for the papier-mâché lids (see page 15)

The decoration:
Plaque A: Copper-paint spray; sea shells
Plaque B: Bones (chicken or rabbit)

Other requirements:

Tray the size of the proposed plaque (eg a plastic meat-tray)	Strong glue
	Glue brush
	Hook or string
Sandpaper	Paste and brush

STEP-BY-STEP

Making the papier-mâché
1 Make the mâché as for the lids (see page 15).
2 In addition, tear strips of newspaper approximately the length of the tray.

Forming
1 Paste the strips and place them at the bottom of the tray, pasted side up.
2 Follow the strips with a layer of pulp.
3 Add a further layer of strips, and thus alternate the layers of strips and pulp until a plaque of the required thickness is formed. The strips reinforce the block.
4 Make a loop from string or hook for hanging the plaque.

Drying
Dry the papier-mâché plaques as for the lids (see page 15).
Drill a hole in the plaque for hanging.

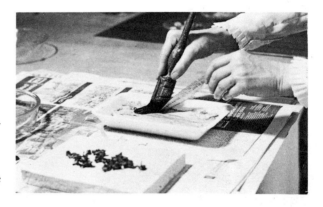

Decorating
Plaque A:
1 Place plaque on a sheet of newspaper and turn up the corners of the paper to form a trough, which will confine the spray.

2 Spray the plaque completely with copper paint.
3 Sandpaper the plaque when dry to obtain an interesting uneven effect.
4 Arrange the shells.
5 Glue the shells on to the surface of the painted plaque.

Plaque B:
1 Sandpaper the plaque until smooth.
2 Place the bones in a hot oven to burn off the remnants of flesh and singe the bones a deep brown. Alternatively, the bones may be buried in the garden for a while where ants and soil bacteria will remove the flesh.
3 Arrange the bones and glue them to the sandpapered plaque.

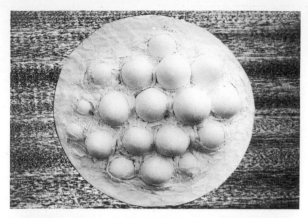

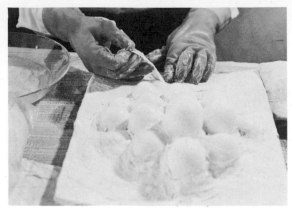

EXAMPLES

'Eggshell Relief'. Eggshells glued on to a papier-mâché plaque and their edges covered with wet strips of gesso (cotton canvas impregnated with plaster) soaked in water

'Acrylic Paint Relief'. Wet gesso strips embedded into and sometimes covered with, thick layers of acrylic paint applied on to a papier-mâché plaque with a palette knife

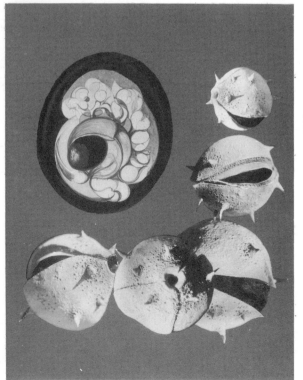

'Beads & Strings' by Ann Stern, London College of Fashion & Technology

Collage and ceramic sculpture, inspired by conkers

WATER-HOLE

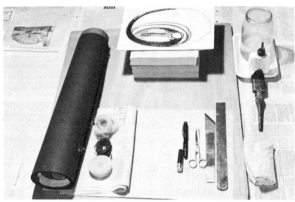

DESCRIPTION
17in × 12in
Inspired by erosion in a cave.
Represents a well-like eroded hole, the black curves giving depth.

METHOD
Cut out the ovals and paste them on to the base. Prick the damp tissue with a pin and peel the tissue in some places to expose the background. Then decorate with plumber's hemp and strings to make an attractive and interesting collage.

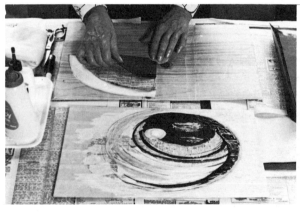

MATERIALS

Base, either chipboard, grained wooden board or cardboard which can be covered with wood-grained wall-paper or coarse fabric

Newspapers, for one oval and to protect working area; white tissue paper, 17in × 12in; dark sugar-paper, either brown or red, 10in × 10in; black glossy paper, 10in × 10in

Pins for holding down glued strings

Transparent glue, eg paste, for paper; cow gum or rubber cement for strings and threads; brush for application of glue

Strings, woollen threads and plumbers' hemp

Scissors

Clean cloth for pressing down the pieces and cleaning hands while at work

Felt marker or brush and ink

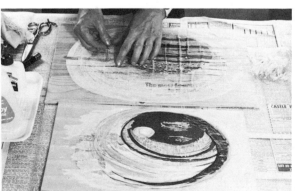

STEP-BY-STEP

The Ovals

1 Fold each sheet of paper into four and cut out four ovals, the largest from white tissue paper, diameter 15in; the next largest from newspaper, diameter 13in; the next largest from dark paper, diameter 9in; the smallest of all from white paper, with a diameter of 2in.

2 Paste the ovals in the following order: newspaper; dark paper; tissue paper *covering both*. Place the smallest oval aside.

3 Before the paste dries, lift the damp tissue gently with a pin and tear narrow strips to expose the dark oval underneath.

4 Leave the ovals to dry.

The Curve

1 Add upswept curves with felt marker. This accentuates the depth of the water-hole.

2 Outline and make an additional upswept, black curve on the reverse side of the glossy paper.

3 Cut out the glossy crescent, paste the shape and add the smallest, white oval.

Details

1 Apply stronger glue along the dark lines.

2 Cover the sticky curves with plumbers' flax . . . and dark strings.

3 Cover the whole collage with clean paper, place heavy books on top and leave to dry.

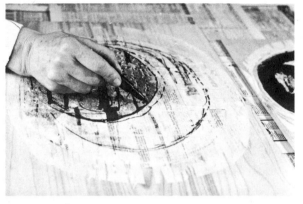

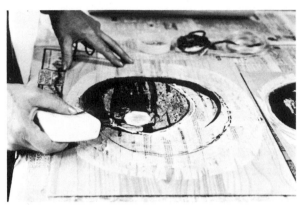

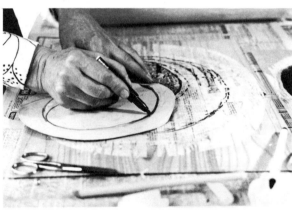

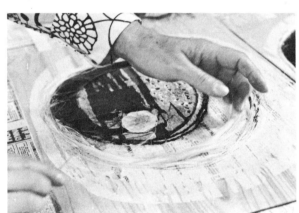

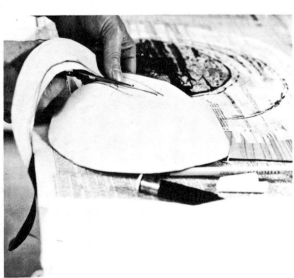

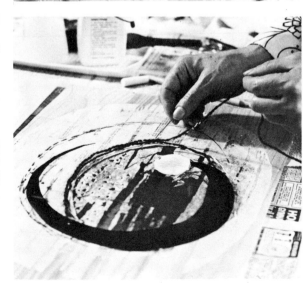

Further suggestions for inspiration (left to right): iron stone, photographed in the Geological Museum, London; *Greek Sculpture; troglodite dwelling in the Sahara desert*

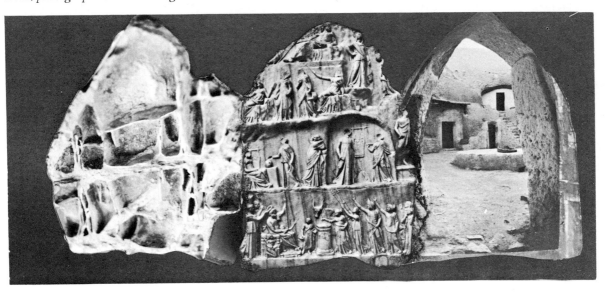

HALF AN APPLE

DESCRIPTION

15in × 19in

Process inspired by the texture of fractured marble from the Geological Museum, London.

Half an apple represented by outlined circle with singed and smudged crescents divided by a core of string and pips.

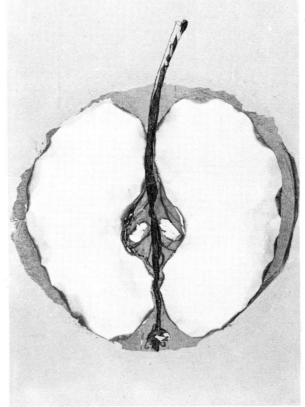

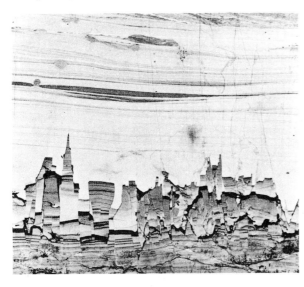

METHOD

Cut out two crescents and singe their edges with the aid of a candle and glue them on to the base. The centre is made from string and pips.

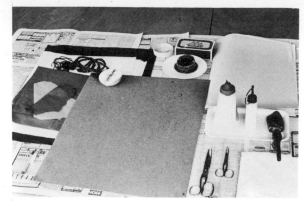

MATERIALS

Inspiration
Stiff board or chipboard
Transparent glue, eg paste, for paper; stronger glue for the string; brush to apply the paste
Thick string or woollen thread in a dark colour, length 17in
Pips or beads
Felt marker, chalk, or brush and ink
Clean rag

Dark tissue paper, 15in × 19in for circle of radius 5½in; stronger white paper, 12in × 12in for the singed crescents; newspapers to protect working area; clean sheet of paper for pressing down the work
Candle and matches
Heavy books for pressing down drying collage

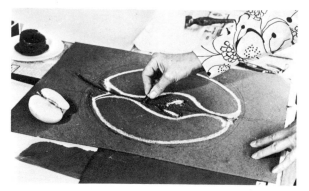

STEP-BY-STEP

Outlining on the base

1 Draw a circle radius 5½in on the base.
2 Draw two equal crescents representing the flesh.
3 Mark the stem and the pips.

Dark circle

1 Lightly fold the dark tissue (15in × 19in) into four, the middle-tip touching the centre of the drawn line.
2 Draw on it a curve of radius 5½in.
3 Tear the circle along the marked curve.
4 Paste the base and place the dark circle on it. Press it down with circular movements to exclude air bubbles.

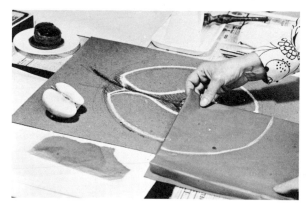

White crescents

1 Fold the stiff, white paper in half.
2 Mark a crescent of radius 5¼in.
3 Cut boldly around the line for angular edges.
4 Singe the edges of the crescent with a candle flame by holding it securely in the right hand over the flame, so that the paper is smudged with the soot and slightly burnt at the edges. Where necessary, extinguish the flame at the edge with a rag held in the other hand.
5 Cover the crescents with paste.
6 Place the crescents symmetrically on to the dark circle.
7 Cover the crescents with clean paper.
8 Press the crescents down with a clean rag as before.

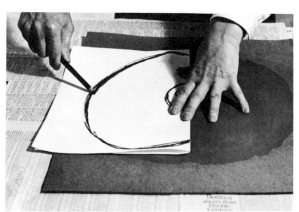

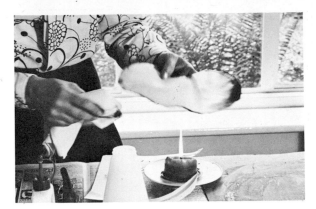

The Core

1 Measure a 17in length of string and splice it in the middle for about 5in.
2 Apply strong glue to the base, along the stem and core line.
3 Press the string into position.
4 Pin down the string with pins until dry.
5 Glue pips in the middle of the core.

Drying

1 Cover the whole collage with clean paper.
2 Press down with weighty books.

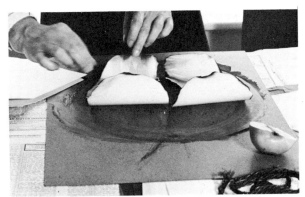

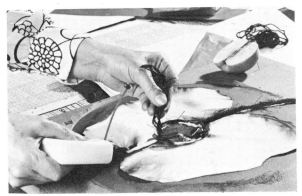

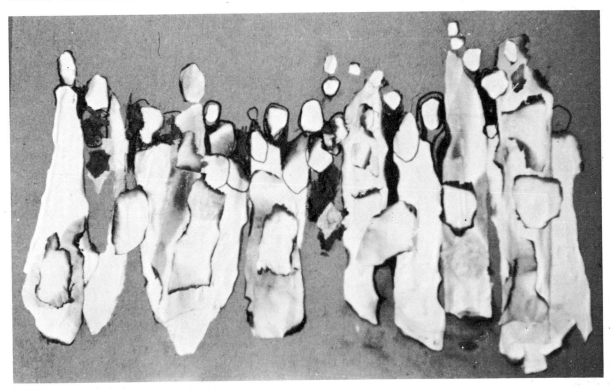

EXAMPLE
'Matmata'

FABRIC COLLAGES

STAPLER

DESCRIPTION

25in × 20in
Inspired by the shape of a stapler.
Stapler is covered with small frayed squares of magenta fabric. The background is of smooth, narrow parallel ribbons of silk.

METHOD

Sketch the stapler with a brush as two oblongs and an oval, and then cover with fraying and overlapping squares of coarse fabric. Cover the surrounding space with torn ribbons of smooth fabric.

MATERIALS

Stapler
Oddments of fabric, same colour but different weaves: smooth fabric, eg silk, which may be torn into ½in strips for the background; coarse fabric, cut into rough ¼in squares and frayed at edges

Hardboard base
Woollen yarns and threads
1 button for the detail
Transparent, strong glue, eg vegetable glue, suitable for fabrics
Black ink and brush
Pencil
Scissors

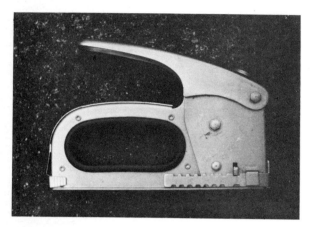

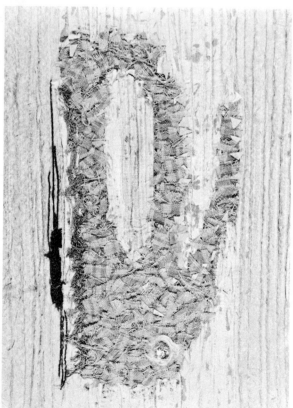

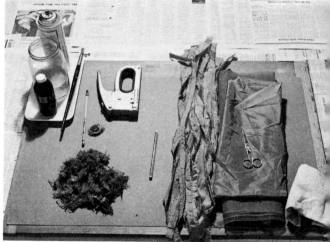

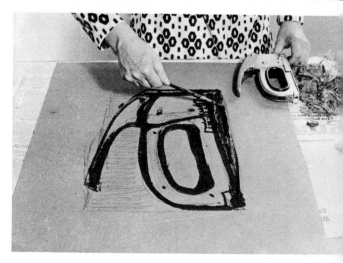

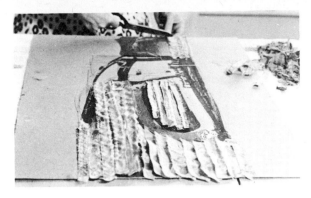

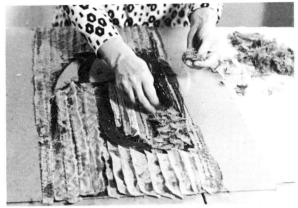

Drawing the stapler

1 Draw 16in × 9½in oblong in pencil on the base.

2 Outline the shape of the stapler inside it, marking the handle and screw.

3 Outline the stapler boldly in black ink. Some of the outlining should show through the glued pieces.

Gluing the pieces

1 Cover the empty oval within the stapler with glue.

2 Select short, 8in long ribbons and place them side by side on to the glued section.

3 Trim the surplus unglued parts of ribbon.

4 Coat the rest of the space around the stapler (but within the oblong first drawn) with glue and cover it with longer strips of ribbon, side by side.

5 Cover the stapler's shape with glue and stick on the small, fraying squares of fabric so that they overlap to form a scaled effect.

Covering the background

When the stapler and oblong are completely covered, coat the rest of the background with glue and apply the strips side by side as before, in the same direction.

The detail

1 Outline the stapler with woollen threads to emphasise its silhouette.

2 Glue the button on for the screw. Leave to dry.

EXAMPLES
'Latticed Window'
'Peeling Door'

UPTURNED CHAIR

DESCRIPTION

15in × 19in
Inspired by an upturned chair.
A vermilion fabric collage represents an upturned chair. The legs in the foreground are of smooth, padded material, whilst the receding pair are of raffia and threads. A shaded effect is produced by net on coarse linen fabric which forms the background.

METHOD

If a chair is not available, or proves too bulky, a photograph or rough sketch of it is referred to throughout the process.

First outline the U-shaped legs to scale, initially on cardboard and then on strong paper to form patterns for the padded and raffia legs respectively.

MATERIALS

Upturned chair, or photograph or sketch of it
Needle and thread
Fabric: coarse linen to cover the frame; foam

Wooden frame, 15in × 19in
Raffia and threads
Stapling gun and staples
Cardboard for the pattern of the prominent legs
Strong paper for the pattern of receding legs
to back and underline the linen background; foam, or wadding, for padding U-shaped legs; velvet or felt for the prominent legs; net for shading
Strong glue for prominent legs (optional)

STEP-BY-STEP

Mounting the linen
As indicated on page 101.

Laying out
1 Mark on the cardboard the lines indicated on the photograph and draw the arched shape, or sketch the chair free-hand on to the cardboard.
2 Cut out the arched shape.
3 Place the shape on to the stiff paper and cut out a second, identical shape.
4 Turn the two shapes upside-down and place on the

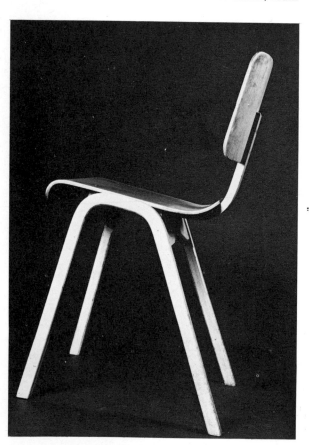

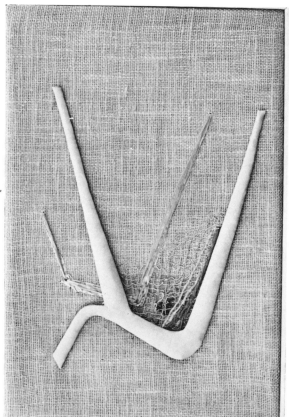

28

linen background; place the stiff paper shape behind the cardboard shape, which is in the centre of the collage.

Receding legs

1 Using the paper shapes as guides, stitch or glue the net and then embroider details with various threads.
2 In place of the stiff paper, stitch the raffia on to the linen to represent the receding legs.

Prominent legs

1 Place on the table, in order, the velvet or felt, 'right' side downwards; the foam or wadding; the cardboard shape.
2 Pin all the layers together.
3 Cut round the shape, allowing for a generous seam. The edges should overlap underneath the cardboard.
4 Cover the shape by pinning and then sew or glue the edges together on the underside.

 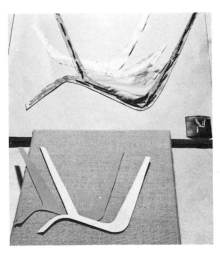

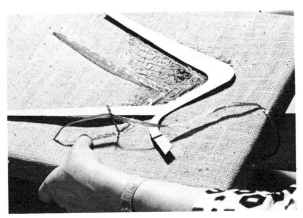

Mounting

1 Place the padded shape in position in the centre of the collage.
2 *Either* glue the shape on to the linen, by applying a powerful adhesive to the shape itself; *or* pin into position, tack, and whilst holding, slant-stitch the shape from underneath. Stitch only the underside of fabric so that the stitching is not visible from the top side.

EXAMPLES

'Monterey'. Quilted and padded velvet and batik on silk. Inspired by fossilised wood

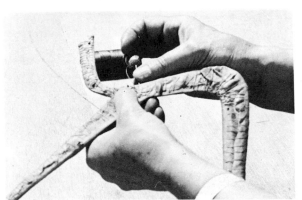 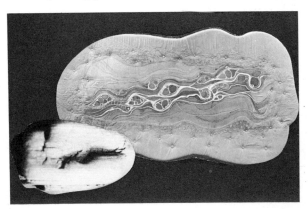

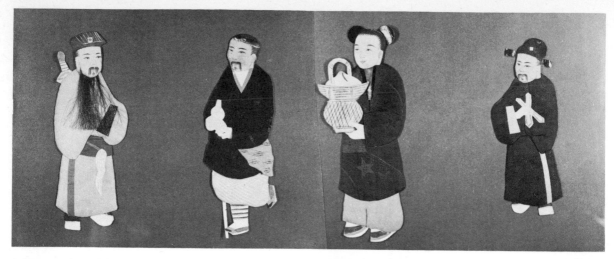

'Chinamen'. Padded figures in fabric and paper from China (age unknown, courtesy Roy Chippett, Putney, London)

'Elisar'. Silk noil and woollen sliver

'Cross-section of Fingernail' by Margaret Godwin, Digby Stuart College of Education, London. Batik-padded embroidery

'West Hill in Fog'. Appliqué of tie-dyed silk, net and machine embroidery

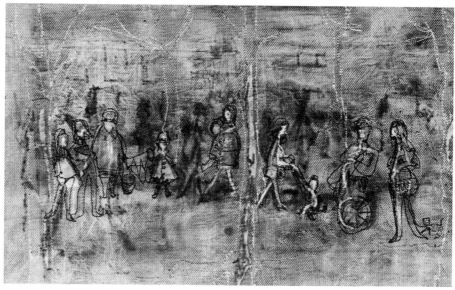

MARBLING

DRIBBLING

DESCRIPTION
16in × 16in
Inspired by a cross-section of weathered bone.
Criss-cross network of bold lines formed by dribbling process (described below) which produces lines of varying thickness, running together and crossing at many angles.

METHOD
Apply drops of ink on to paper which is then tilted to make the ink run down it thus producing the dribbles. The more vertical the paper is held, the quicker the ink will run down the paper, and so the thinner the lines produced. By holding the paper appropriately, the direction of flow of the ink can also be regulated and so the position of the dribble on the paper.

MATERIALS
Inspiration
Various coloured inks, poured into small plastic bottles with dribbling teats
Rags for wiping
Brush (as an alternative to the bottles)
Sheets of paper
Newspapers to protect working area

STEP-BY-STEP

First colour application

1 Fold the paper lightly into an 'M' shape and apply blobs of ink, either straight from the teat-bottle or with a brush, on to the folds at regular intervals.
2 With both hands, unfold the paper, still holding both ends uplifted and so directing the dribbles of ink towards each other at the centre of the paper.

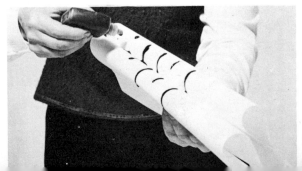

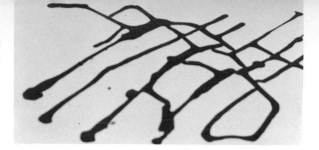

3 Add further blobs of ink where desired and make thick or thin dribbles by tilting the paper at the angles required, and directing the flow of ink.

Second colour application
Repeat the dribbling process with a differently coloured ink on to the same piece of paper, either when the first ink is still wet (to form a pattern with the two inks merging) or when it is dry (to form merely a criss-cross pattern of differently coloured lines).

Diagonal dribbles
Pour ink on to the corner of the paper and lift the corner off the table and direct the flow diagonally.

Cutting out
Cut out the dribbles and paste them together to form the desired pattern.

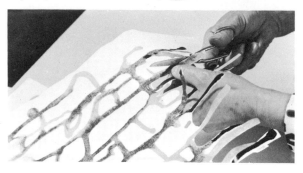

EXAMPLES
'Bacteria' by Diana Harris, Digby Stuart College of Education, London. Inspired by a mouldy cheese sandwich

'Sea Shore'

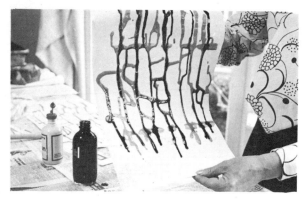

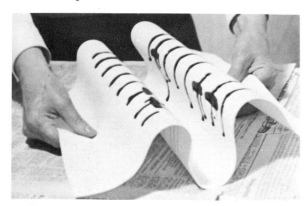

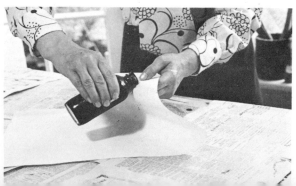

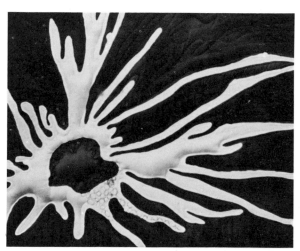

FLOATING

DESCRIPTION

15in × 10in

Inspired by the movement of air-currents and the flow of water.

Intricate curving and blending patterns, representing interaction of flowing streams of particles of air or water, formed on paper or fabric.

METHOD

Apply oil-based colours on to surface of water in a trough. Although colours do not mix with water, they may be floated on top and merged to form mobile, curving patterns. When an attractive pattern is formed, place paper quickly on to the surface to pick up the pattern, whilst the water drips off. If colour needs to be replenished after several dips, the colour added will produce darker stains on to subsequently dipped paper.

MATERIALS

A trough or similar vessel at least 3in deep, size 24in × 14in
Either turpentine *or* white spirit (both should not be mixed)
White or lightly coloured paper, or silk or cotton stretched on to a frame, size 22in × 12in (see page 101)

Tubes of oil paints
Eggshells or egg-cups for mixing the paints in
Sticks for mixing paints
Brushes
Rubber gloves
Newspaper
Rags
Spoon

STEP-BY-STEP

Preparation

1 Cover table with plenty of newspapers, and clear enough space for the drying prints.

2 Dissolve oil paints in turpentine or white spirit

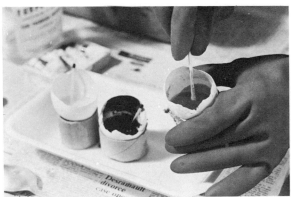

about three hours prior to the printing. Squeeze a 2in length of colour into half an eggshell or cup, and add a tablespoon of solvent. Stir until they dissolve.
3 Fill the trough with water to a depth of 3in and place a tablespoon of turpentine on the surface to aid floating the colour. Place a small drop of colour on to the surface of the water to test if it floats. If it does not, add more solvent to the colour until it does float.
4 Cut paper to be dipped and coloured into oblongs an inch smaller all round than the trough.

Printing

1 Dip brush into the colours and splash spots of colour on to the surface of the water. The normal air-currents make the spots glide and merge on the surface and the movement may be aided by blowing gently along the surface.
2 When an attractive pattern is formed, quickly lower the paper on to the oily surface, ensuring that all the surface of the paper is in contact with the floating colour by tapping the paper gently to exclude air bubbles.

3 Remove paper by lifting it gently by its edges and lay it, face upwards, on to newspaper to dry.
If a frame of fabric is being printed the process is identical except that the frame is lowered on to the surface and held in position over the surface and then removed and dried.

Cleaning the Trough

1 Cut newspapers into 2in strips.
2 Drag newspapers over the surface of the water to collect and absorb the remains of the colour to be removed.
3 When the surface has been thus cleaned, apply fresh colours and continue printing.

Variations

1 Various colours may be applied on to the surface of the water at one time to produce a multi-coloured marbled pattern.
2 A pattern comprising different shades of the same colour may be produced by replenishing the surface with the same colour at intervals.

Finishing

Cut out and superimpose the marbled paper to obtain the desired seascape.

EXAMPLES
'Whisper'

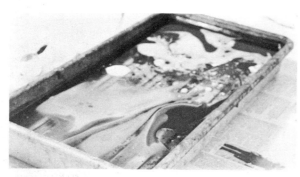

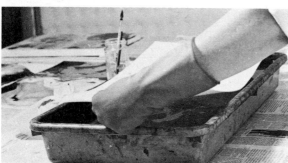

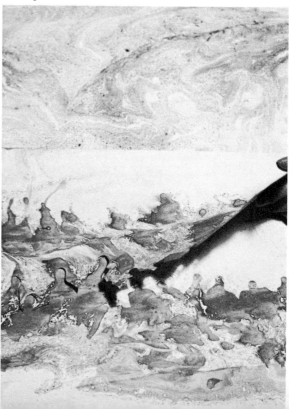

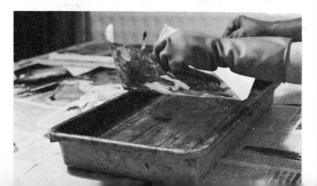

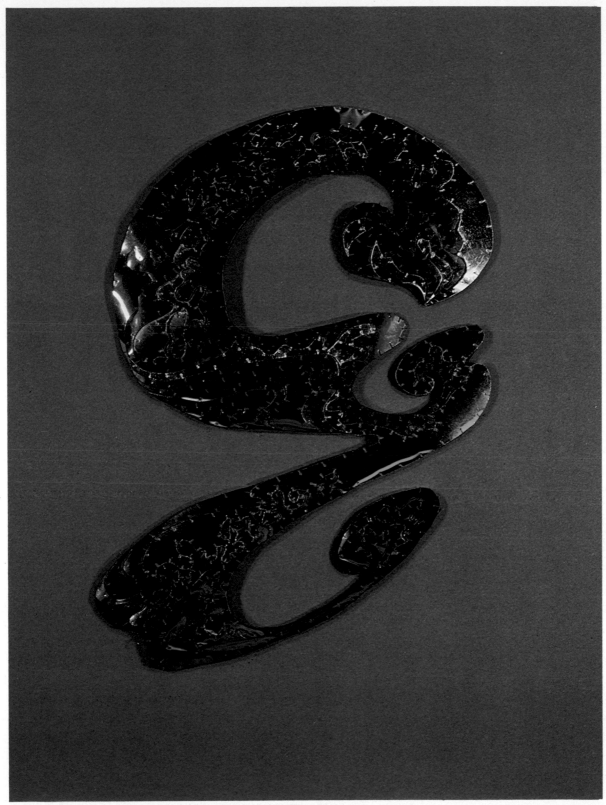

'G' by Joan Sutherland, London College of Fashion and Technology

'Snowflake'. A paper cutting

'Susalito'. An organdie collage

'Ondine'

'Firebird'

MARBLE LANDSCAPE

DESCRIPTION
21in × 15in
Inspired by marble cross-section from the Geological
Museum, London.
Cut-out pieces of marbled paper fitted together, form
serene, green and blue collage of English landscape.

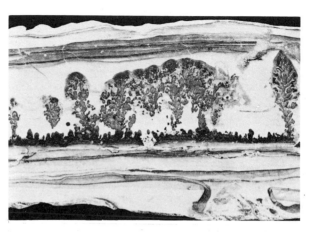

METHOD
From the inspiration, cut out various shapes required
from plain paper to form patterns for subsequent
pieces. Then use selected marbled sheets for these
pieces.

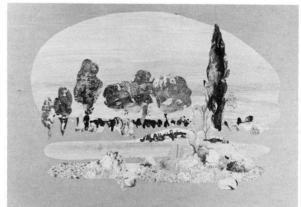

MATERIALS

Inspiration
A stiff base (eg
 hardboard)
Green and blue marbled
 paper
Plain thin paper for the
 patterns of the pieces
Newspapers to cover
 working surface

Paper and books for
 pressing collage
Scissors
Talcum Powder
Paste
Paste brush
Clean rag
Pencil

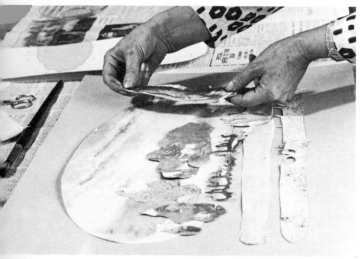

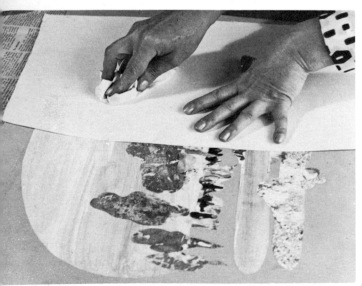

Making the Patterns

1 Lay a thin piece of paper on the board and sketch main features of the 'landscape' from the marble.
2 Cut out the shapes thus drawn.

Cutting Out and Pasting

1 For each shape, choose the appropriate marbled paper, using the inspiration as a guide for selection.
2 Using the plain pieces as a pattern, cut out the shapes from the marbled paper.
3 Powder the fingers with talc to absorb finger grease and so prevent soiling of the collage.
4 Arrange the pieces on the board.
5 Paste the wrong side of each piece one by one and place it gently in position on the board.
6 Cover the piece with a sheet of clean paper and rub this with a clean rag.

Drying

When all the pieces have been stuck on, cover the completed collage with a clean sheet of paper, press with heavy books, and leave to dry.

EXAMPLES

Addition of pressed plants to a marbled background

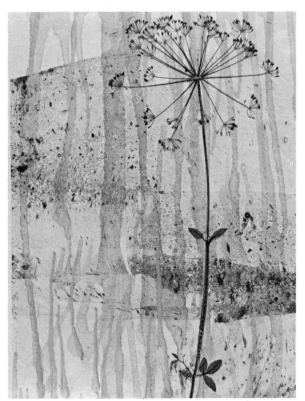

EMBROIDERED COLLAGES

CRUMPET COLLAGE

DESCRIPTION

8in × 8in

Inspired by burnt crumpet resembling moonscape. Round and holey, comprises overlapping rings of natural-coloured hemp, wool and string.

METHOD

Trace pattern on to acetate material. Stretch material on to an embroidery frame. Then mount rings of hemp on to the acetate by machine-embroidery. Cut out unembroidered parts of the acetate from around the rings, and remove the rest by plunging the circle into a bath of acetone.

MATERIALS

The inspiration
Paper and pencil
Embroidery frame
Chalk or coloured pencil of a light shade
Sewing machine with a darning foot
Sewing-machine embroidery threads. These *must* be cotton or silk, ie insoluble in acetone
Coins and/or compass
Small scissors, eg nail scissors
A dish for the bath of acetone

Rags
Piece of natural-coloured or white acetate fabric (eg tricel)
Lengths of wool, string and hemp (insoluble in acetone) 'Plumbers' hemp', used for insulating pipes, may be used
Acetone, eg colourless nail-polish remover
Tweezers or gloves
Wooden board
Metal ring for mounting

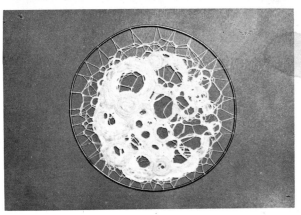

STEP-BY-STEP

Preparation

1 If plumbers' hemp is used, wash it thoroughly in detergent until no more colour comes from it. Dry it and comb, until the hemp resembles coarse hair.

2 Assemble all threads and yarns to be used for the rings.

3 Draw the pattern on to paper the same size as the acetate by means of coins and/or compass.

4 Stretch the acetate on to the embroidery frame, making sure it is really taut.

5 By means of a coloured pencil of a light shade, or chalk, transfer the pattern on to the acetate on the frame as guidance for embroidery.

The Embroidery

1 Thread the machine.

2 Place the embroidery frame under the foot of the machine.

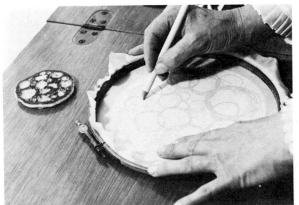

3 Take a strand of plumbers' hemp and twist it to form a roughly spun yarn.

4 Wind the piece around the fingers a few times to form a ring of the required size.

5 Place the ring in the required position on the acetate, tuck the loose ends well under the coil and stitch it on to the base in circular lines, making sure the ends are well fastened.

6 In the same way, stitch the rest of the rings on to the acetate, varying the yarns used.

Removing the Acetate

1 With a pair of small nail scissors, cut or remove embroidery from the frame.

2 Cut around the rings to remove the unembroidered part of the acetate.

3 In a well-ventilated room, pour acetone into a dish on a wooden board. (Acetone is inflammable and so all naked flames should be extinguished beforehand.)

4 Pour more acetone on to the embroidery in the dish and agitate it for a few minutes until the acetate is dissolved away from the rings, leaving the holey collage.

5 Remove collage from the dish (with gloves or tweezers) and leave it to dry. Meanwhile pour the acetone safely away.

Mounting

By means of the embroidery threads, catch the edge of the collage on to the circle of metal to frame it.

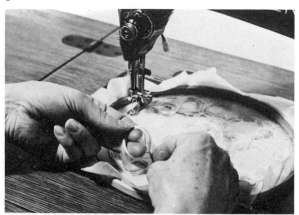

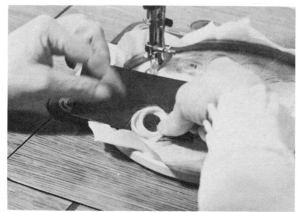

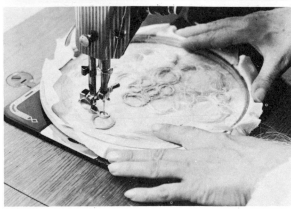

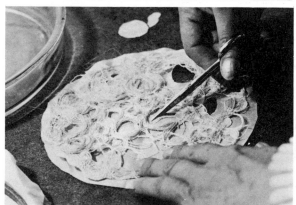

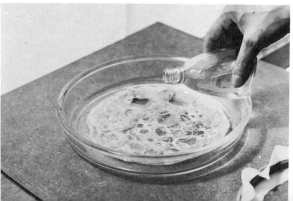

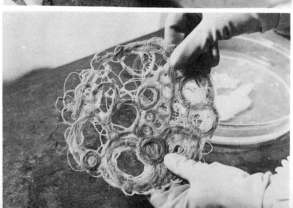

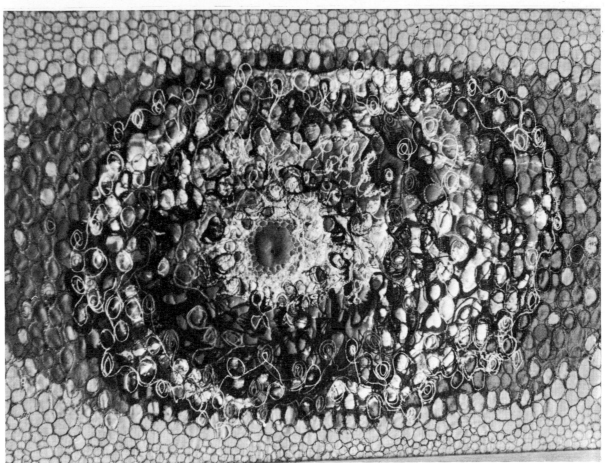

EXAMPLES

'Harmonium'. Inspired by sinew of sea-urchin (microscopic photograph from Textile Physics Laboratory, University of Leeds)

'Dahlia'

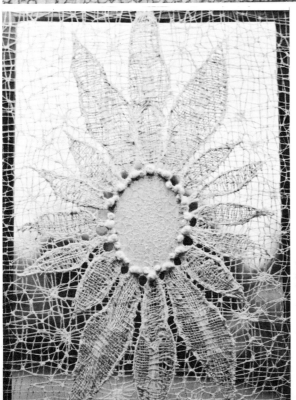

HEART VENTRICLES

DESCRIPTION

14in × 18in

Inspired by sketch of the inside of the human heart. Oval, translucent collage of orange and vermilion organdie and acetate, with machine-embroidery resembling spider's web across the spaces, and wool and sisal threads around edge and ventricles.

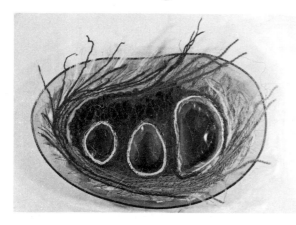

METHOD

Use a sketch of the final product as a guide. Stretch the vermilion organdie on to a metal frame, bent to the right shape, and then machine the orange organdie and the various threads on to it. Cut out the organdie around the three holes representing the ventricles and machine 'spiders' webs' across the spaces (other than the holes) formed.

MATERIALS

Sketch of the inspiration	Vermilion and orange
Threads: wool and	organdie of different
cotton, various shades	shades
of red; natural-	Thick metal wire
coloured sisal or	Sewing machine with a
plumbers' hemp	darning foot
Red machine-embroidery	Small scissors, eg nail
threads (nos 30 or 50)	scissors
Tailors' chalk or crayon	Red acetate paper

Preparation

1 Bend the wire into an oval for the frame.
2 Cut the vermilion organdie to the shape of the frame, leaving an ample overlap margin.
3 Mount the organdie by pinning round the frame. Make sure it is stretched tightly with the grain parallel to the longest sides of the frame. Baste the organdie on to the frame.
4 Machine the organdie on to the frame to make it firm and trim off the excess fabric.
5 Place the sketch, face up on to the table. Place the organdie frame, right side up, on to the sketch.
6 Place three layers of orange organdie on to the frame.
7 Pin the layers of organdie to the frame.
8 Trace the pattern through on to the top layer with a crayon.
9 Baste the orange layers on to the frame along the lines of the pattern.
10 Cut out the outer edge of the orange organdie.

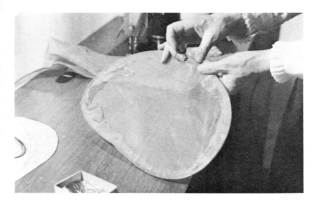

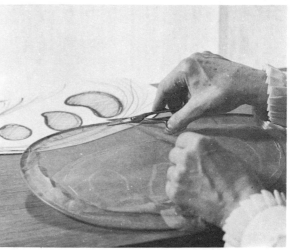

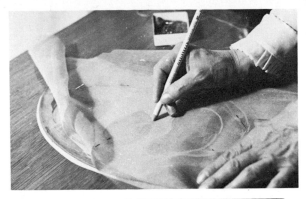

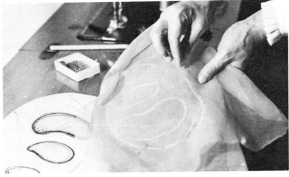

Machining

1 Cut lengths of wool and sisal to fit around the edge of the orange organdie.

2 Thread the machine and attach the darning foot.

3 Place one length of a thick thread along the edge of the orange organdie and machine along it, thus sewing both the thread and the layers to the base, leaving the ends of the thread loose.

4 Continue to machine a few of the threads around the edge.

5 Cut lengths of sisal to fit around the circles drawn in the middle of the collage.

6 Place the rings on to the holes and machine them on, tuck the loose ends well under and secure them firmly.

7 Cut out the actual holes.

8 Begin to cut around the sisal rings with a pair of small scissors.

9 Begin to machine the 'spiders' webs' across the gaps thus formed from the threads and organdie at the edge, to the sisal framing the holes at the centre, and back again.

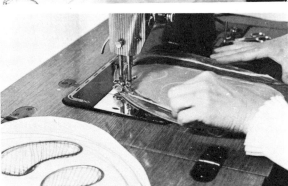

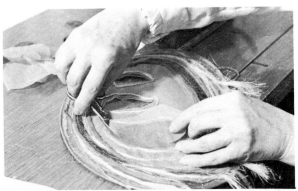

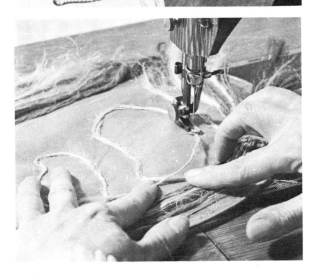

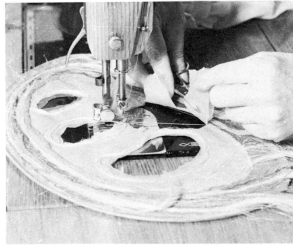

Step 9 above requires some practice. The material must be kept taut throughout and the frame must be moved rhythmically and smoothly to and fro while the machine is 'sewing' across the spaces.

10 Continue to make the webs across to the spaces. Cut out around the holes.

11 When the webs are complete, stitch circles across the criss-crossed threads to tighten them and bring them together to form interesting web-like shapes.

12 Make the whole collage taut by machining final threads around the edges.

Completing

1 Trim around the inside of the ventricle holes and trim and fray the threads edging the collage. Remove any basting threads.

2 Cut a piece of red acetate paper to the same size and shape as the collage and attach it underneath.

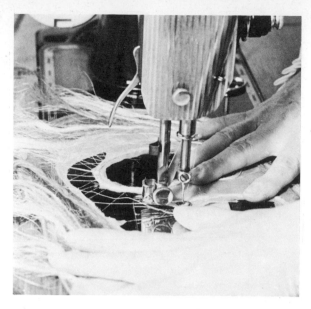

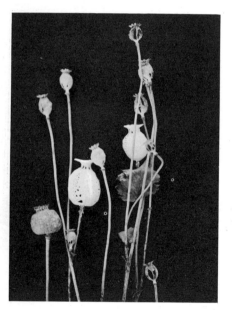
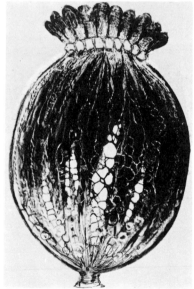
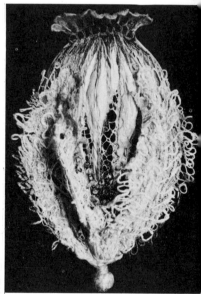

EXAMPLES

(Left) Inspired by poppy pods; (centre) sculptured china-clay pods; (right) fibre sculpture, wall hangings

Lamp in the shape of a pod

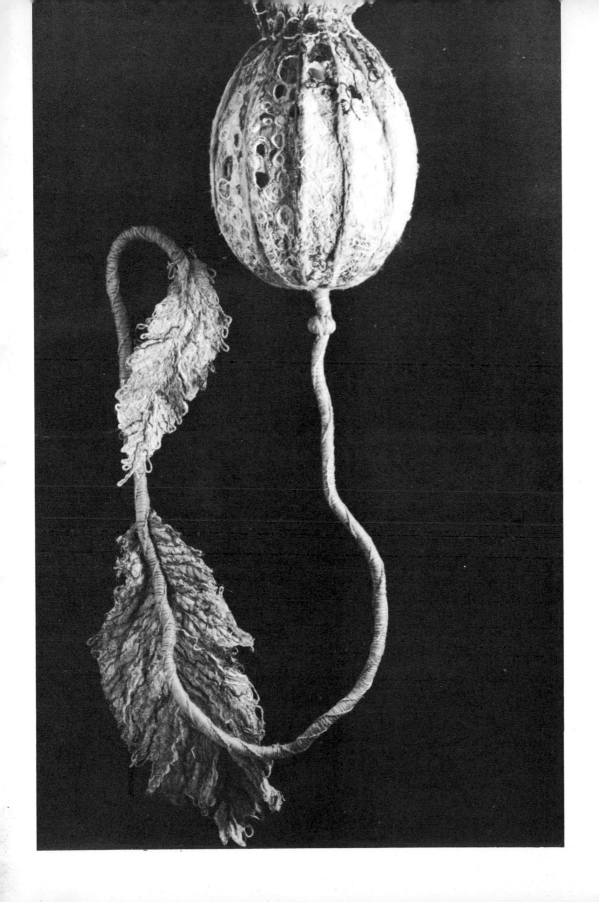

GLUED COLLAGES

POSTER COLLAGE

DESCRIPTION

Inspired by a statement 'Books are food for thoughts'. Colourful poster from pasted-on magazine clippings illustrates the statement.

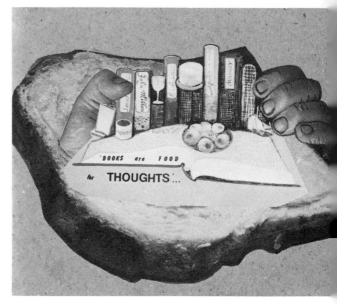

METHOD

Plan the poster, then cut out from magazines, etc colourful pictures of food and from coloured paper suitable shapes for the design (eg, oblongs for the book spines; white, curved shapes for the pages). Paste on. Lettraset letters may be used too for the statement.

MATERIALS

Board or stiff paper for the background	Plain white paper; white tissue or lace paper; coloured paper
Magazine cuttings	
Sheet of Lettraset	Pencil
Paste	Talcum-powder to prevent greasy fingermarks (optional)
Rag	
Ruler	
Brush	

STEP-BY-STEP

Laying Out and Cutting Out
1 Decide on the poster design.
2 Cut out suitable pictures of food from magazines.
3 Cut out the curved shape of the bulk of the book from white paper; the shape of the open pages from lacy or tissue paper; the book spines from coloured paper and from the magazines; the titles of the books from the magazines.
4 Arrange the pieces on to the background.
5 Mark their positions with discreet dots.

Pasting
Paste the pieces of paper on, one by one.

Lettering
1 With a ruler, mark the position of the lettering.
2 Cut out the corresponding letters from the sheet of Lettraset, leaving a generous margin of paper.
3 Arrange the letters in order on a separate piece of paper, above the collage.
4 With a pencil, rub the letters in place, one by one.

PHOTOGRAPH COLLAGE

DESCRIPTION
23in × 16in

Inspired by chronological photographs from a family album.

Cut-out photographs of various stages in young girl's life arranged around dominant photograph of her at twenty-one. Background is a simulated stone wall.

METHOD
A sample of simulated brick wallpaper is cut up and pasted on to a board to form the background on to which the cut-out photographs are then pasted.

MATERIALS

Hardboard for the base	Paste
Wooden board	Brush
Assortment of photo-graphs of the subject	Paper
	Newspaper
Oddments of simulated brick and stone-wall wallpaper	Rags
	Heavy books

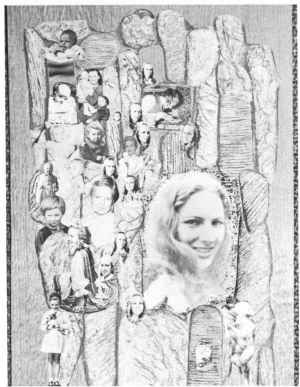

STEP-BY-STEP

Cutting Out

1 Cut out the 'stones' from the wallpaper.
2 Cut out the subject from the photographs.

Pasting

1 Make a sample layout on the background board.
2 If desired, mark faintly with a pencil positions of the important pieces on the hardboard.
3 Cover the mock collage with the wooden board and invert the two, so that the pieces are now face downwards on the wooden board.
4 Gently lift the hardboard off.
5 Place the hardboard on to the newspaper-covered working surface.
6 Paste some of the uppermost pieces of 'brick' and leave them to saturate with the paste.
7 Paste the hardboard background completely.
8 Begin to stick the pasted pieces in the places marked for them; press them down gently with a rag, which also mops up the excess paste.
9 Continue to paste further pieces, leaving them to saturate whilst sticking on other pieces.
10 Cover the finished, but wet, collage with paper, then the board and heavy books to act as weights.
11 Leave to dry.

'Water Nymph'. Photomontage

'Los Angeles'. Inspired by townscape of the city

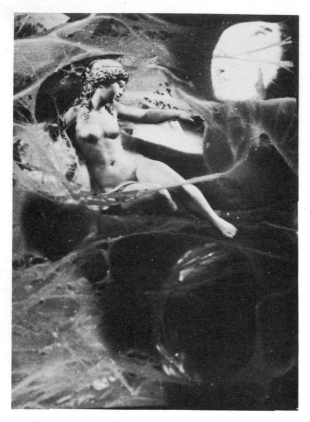

DRIED-FLOWER COLLAGE

DESCRIPTION
16in × 21in
Delicate collage of pressed and dried flowers.

METHOD
Arrange dried flowers and glue on to stiff paper.

MATERIALS

An assortment of pressed and dried flowers	Tissue paper
	Stiff, white paper, size 16in × 21in
Glue	Scissors
Glue brush (if bottle has no dispenser)	Rag
	Newspaper to cover working surface
Spare board	Heavy books
Pencil	

STEP-BY-STEP

Laying Out

1 Choose the flowers and arrange them on the stiff paper to be used as the base.
2 Mark very lightly with a pencil the positions of the flowers on the base.
3 Carefully lay tissue paper and the spare board on to the arrangement and invert the sandwich but do not disturb the arrangement. Thus the flowers are now face downwards on the tissue paper and spare board.
4 Remove the stiff paper and lay it on the working surface, marked side up.

Gluing

1 Apply spots of glue on to the stiff paper where the flowers are to be, using the pencil marks as guides.
2 Gently place the sticky paper on to the tissue with

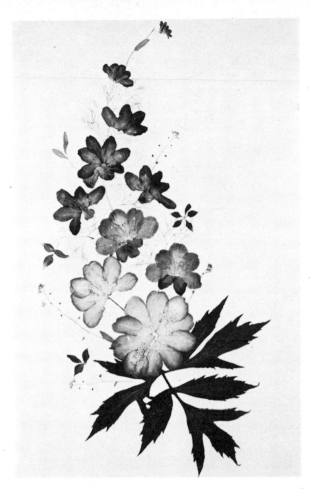

Anonymous Victorian Card. Feathers stuck on to a watercoloured background to form colourful birds (Courtesy of Elena Gaputyte, London)

'The World of Litter' by Vera Mather. Bottle-tops, lollipop sticks, can-openers, etc, stuck on to a circular base and sprayed with silver and gold

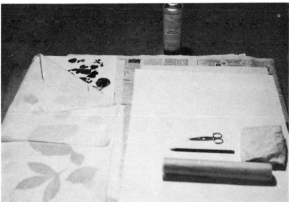

the reversed arrangement of flowers on it so that the sticky spots touch the corresponding flowers.

3 Press the paper down gently with a rag.

4 Leave to dry and press with heavy books.

5 Invert the 'sandwich' again, so that the spare board is uppermost.

6 Remove the spare board and tissue to reveal the arrangement of flowers stuck on to the paper.

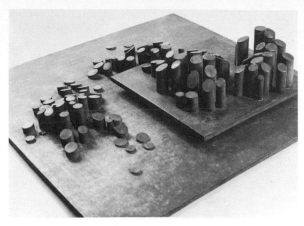

'Brown Seeds' by Belinda Plunkett, London College of Fashion. Wood relief

Folklore Straw Landscape (Mauritius) (Courtesy of John Powell)

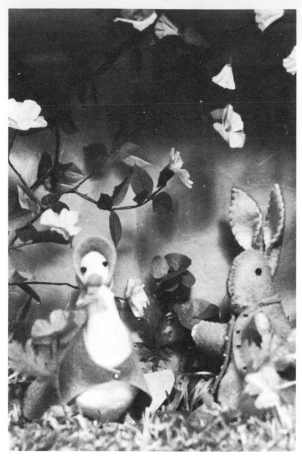

'Tales of Beatrix Potter' by Margaret Norbury. Paper and fabric collage

CHESSBOARD COLLAGE

DESCRIPTION
28in × 20in
Motif inspired by the flight of a moth around a lamp. Geometrical room-decoration simulates a chessboard, with unusual black and white pieces.

METHOD
Cut the black checks to the right size by starting with the white background and the black paper the same size. Cut out identical black and white pieces from folded paper and stick on – white on black and black on white.

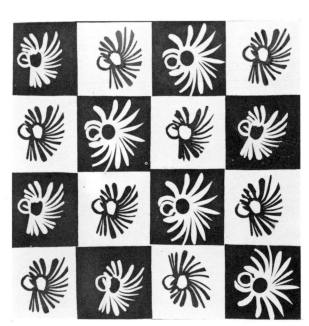

MATERIALS

A firm base (eg hardboard) 28in × 20in
Outline sketch of the inspiration
Paste
Paste brush
Scissors
Paper knife
Pencil
Heavy books
Newspapers to cover working surface

Paper – one sheet of each of the following: thick white paper (28in × 20in); thick black paper (28in × 20in); thin white paper (14in × 10in); thin black paper (14in × 10in)
Ruler
Sheet of paper

STEP-BY-STEP

The Black Checks

1 Paste the thicker white paper on to the base – this will prevent curling.
2 Fold the thicker black paper into accurate concertina pleats lengthwise.
3 Fold the folded length thus formed into accurate concertina pleats widthwise.
4 Slash or cut along the folds to form squares.
5 Arrange half these squares on to the white base.
6 Paste them on to the base.
7 Cover the result with a sheet of clean paper and then press dry with books whilst cutting the next stage.

The Chess-pieces

1 Fold both the thinner sheets into similar concertina squares as above.
2 Trace the outline of the motif on to the top square of both the folded sheets.
3 Cut along the outlines to form the pieces. If the whole folded sheet is too thick to cut at once, divide it and cut a few pieces out at a time.
4 Paste the pieces on to the centres of the check – white pieces on black squares and black pieces on white squares.

Drying

Cover the collage with clean paper and then press dry with weights.

Variations

The chess-pieces may be varied by:
Making them all, or some of them, different shapes.
Varying the colours of the pieces.
Gluing on three-dimensional pieces made from folded or crumpled paper; and so on.

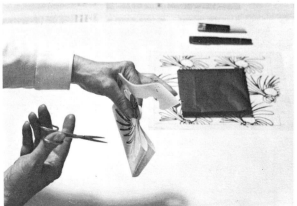

'Sousse'. String and fibre collage ▶

EXAMPLES

'Roses'. Cut-outs from catalogues

Polish 'Wycinanki'. Paper-cuttings (Courtesy of Łowicz Folklore Museum, Poland, photographed by Peggy Mills, London)

'Snowflake' by Wyk Marczewska, Łowicz, Poland

'Two Cocks on a Tree' by Majer Agnieszka, Łowicz, Poland

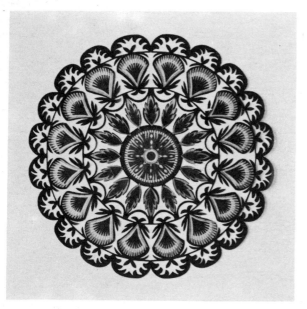

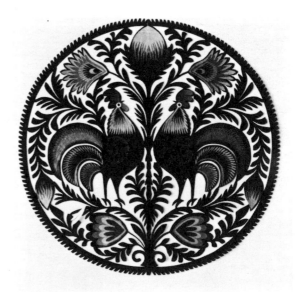

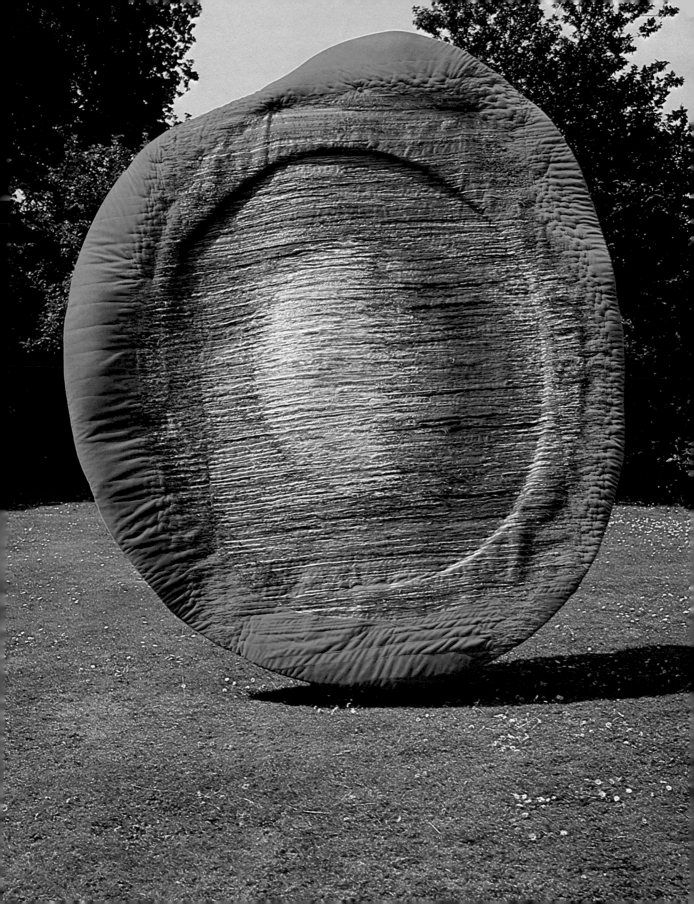

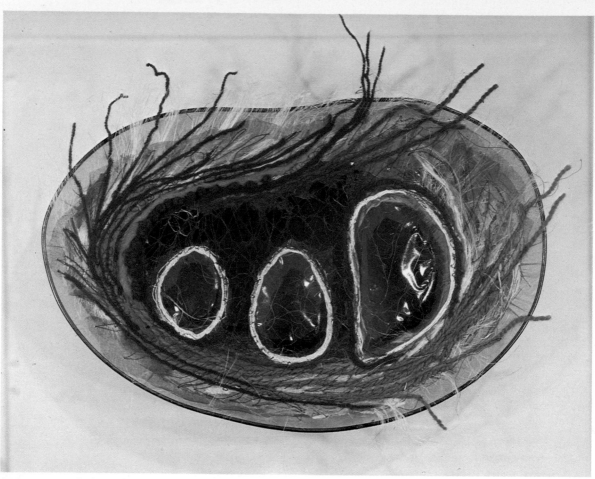

'Heart Ventricles', made of organdie and acetate,
with machine-embroidery across the spaces, and
wool and sisal thread around the edge and ventricles

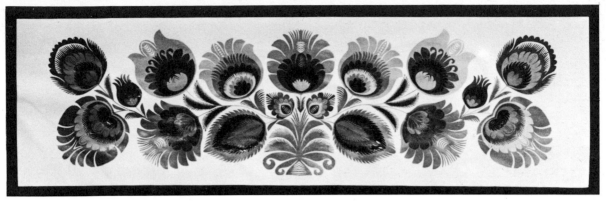

'Flowers' by Lus Henryka, Łowicz, Poland

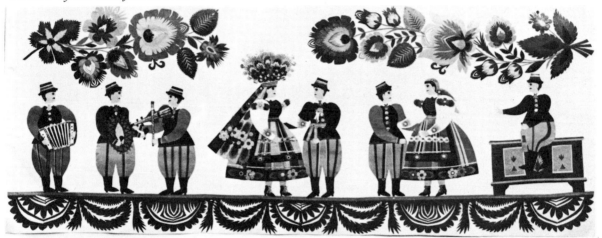

'Wedding' by Majer Agnieszka, Łowicz, Poland

'Easter Postcard'. Cut-outs from gift-wrappers

'Panel' by Jadwiga Lukawska, Łowicz, Poland

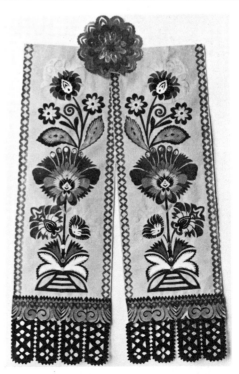

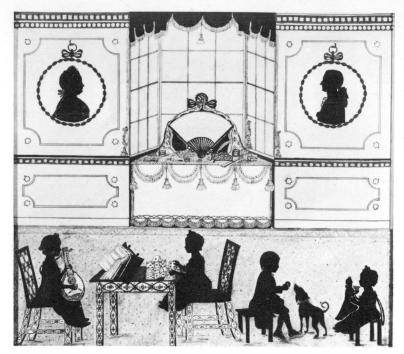

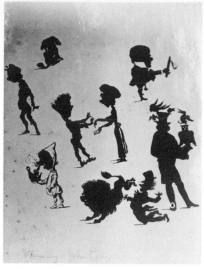

'Whims' by John Parry (1812–65, Victoria & Albert Museum). Grotesque silhouettes of people and animals

SILHOUETTES

'Silhouette Group of John, Earl of Ashsunham and His Family' by John Jollife (1767, Victoria & Albert Museum)

'Transparent Leaf and Cut-Outs' Swiss (1835, Victoria & Albert Museum)

'Pip' (1965)

VICTORIAN VALENTINES

Centre of paper lifted to reveal a trapped mouse

'New Year Greeting Card' (Victoria & Albert Museum).
Embossed paper, litho-print and ribbons

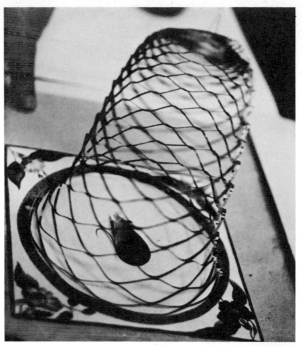

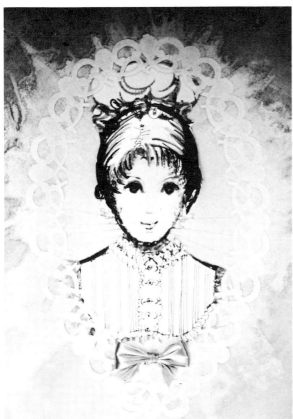

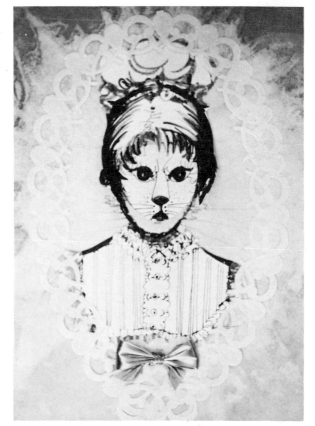

'Trick Valentine'. Inspired by a Victorian Valentine, the drawing is mounted on tie-dye silk and decorated *with cut-out doily and ribbon. A tab is pulled to substitute the girl's face for a cat's.*

TORN-PAPER COLLAGE: HERRING

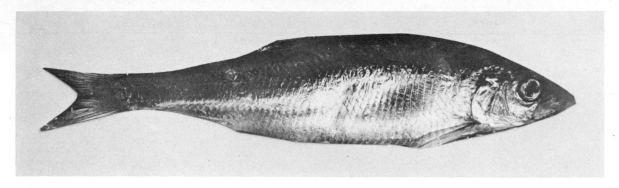

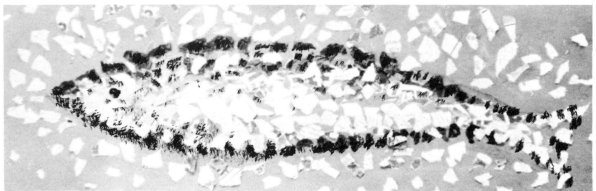

DESCRIPTION

22in × 15in

Inspired by herrings.

Elongated body of herring with pointed snout and beady eye. Dark ridge runs along top and outlines shape, whilst head and underbelly are red and amber. Prevalent colour is grey, with specks of silver, red, amber and blue.

METHOD

Glue sections of the base and cover them with torn pieces of paper.

MATERIALS

Inspiration

A stiff base (eg hard-board)

Paste

Paste brush

Rag for wiping hands and pressing

Felt marker and white chalk

Paper from which pieces $\frac{1}{4}$in to $\frac{1}{2}$in square are torn: newspaper; tinfoil; assorted coloured sweet papers; tissue; cellophane

Clean paper and heavy books for covering and pressing collages whilst drying

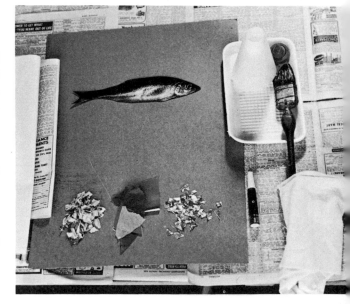

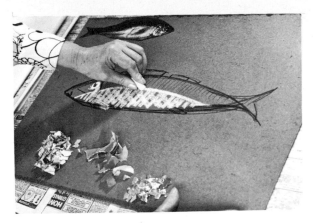 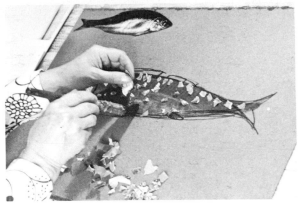

Outlining the Herring

1 Mark 16in × 3½in oblong lightly on the board and draw the shape of a herring inside the oblong with a felt marker.

2 With white chalk, mark the eye, underbelly and tail.

Sticking the Pieces

1 Apply paste on to the base for each individual piece of paper and cover the spot with the piece of paper chosen. Outline the shape with pieces of dark paper, and add the dark ridge. Fill in the shape with the other pieces of paper, doing one colour at a time for convenience.

2 For the background, paste newspaper pieces around the herring to add interest to the dark and sombre background.

GASKET COLLAGE

DESCRIPTION

22in × 16in

Inspired by car gaskets.

Geometrical pattern is built up using basic shape of a gasket.

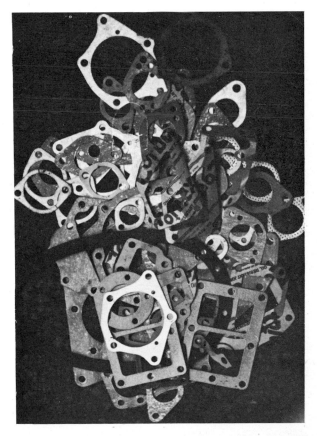

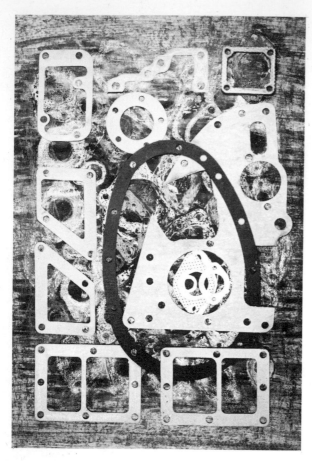

3 Rub the surface of the paper with pale crayons to obtain hardly visible waxy rubbings of the gaskets underneath.

4 Remove the sellotaped paper from the board.

5 Brush the waxed paper with dark ink so that it colours only the unwaxed parts to reveal the pattern of gaskets as pale shapes.

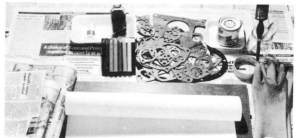

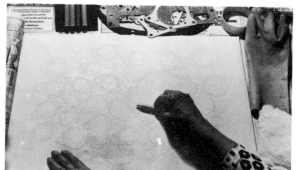

METHOD

To obtain the background pattern of grouped gaskets, cover the gaskets with paper and rub with wax crayons. Then ink the partially waxed paper to colour the unwaxed parts. Glue on painted individual gaskets to complete the pattern.

MATERIALS

Car gaskets	Brushes for ink and glue
2 chipboards	Sellotape
Paper	Gloves
Dark-coloured ink	Scissors
Crayons (assorted colours)	Jam-jar or cup
	Rag

STEP-BY-STEP

The Background

1 Arrange and then glue a pattern of gaskets on to a chipboard.

2 Cover the board, gasket-side up, with paper and sellotape the paper to it underneath for firmness.

6 Leave the paper to dry and then mount on to a second chipboard.

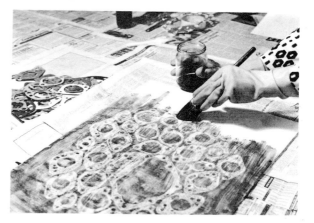

EXAMPLES
'1912 Rolls-Royce' by Ron Wyld

Mounting

1 Rub some gaskets with crayons of prominent colours.

2 Paint other gaskets.

3 Glue these coloured, individual gaskets on to the background to form the final pattern.

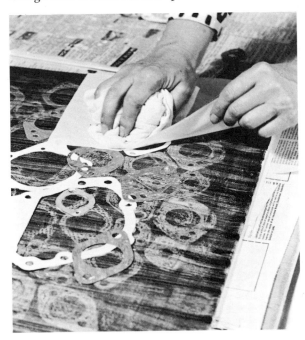

'Hair'. Crayoned and inked papers, scraped in places to reveal the white background

'Pears'

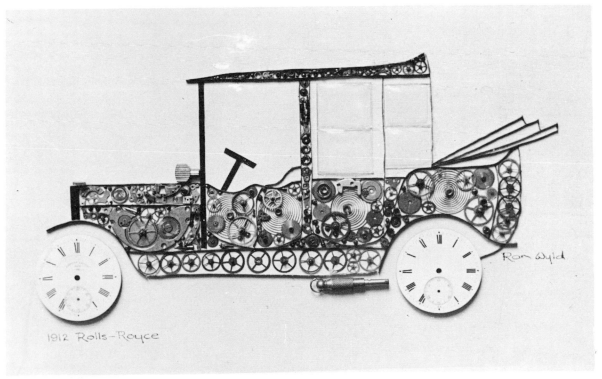

1912 Rolls-Royce

Ron Wyld

STRING COLLAGE

DESCRIPTION
10in × 14in
Inspired by sand-dunes in the Sahara desert.
Natural-coloured collage with three-dimensional wavy effect, formed by touching curved lengths of string completely covering the base.

METHOD
Glue pre-soaked strings on to a wavy pattern sketched on the base. Follow the curves of the sketch with the lengths of string.

MATERIALS

Sketch or picture of the inspiration
Strong board (hardboard or chipboard)
Balls of string of various kinds
Felt pen
Heavy books
Clothes-pegs or bull-clips (optional)
Paper

Strong glue, eg rubber cement or Marvin
Glue applicator (if the glue-bottle has no dispenser)
Pins
Scissors
Photograph or other decorative items (optional)

STEP-BY-STEP

Preparation
1 The day before the collage is to be made, soak the balls of string in brine to soften and facilitate bending.
2 Draw a sketch of the waves on the board with a felt marker. These guidelines will be completely covered by the strings.
3 Measure lengths of pre-soaked string along the curves drawn and allow 2in before cutting.
4 Lay the cut strings out in order of gluing. For greater accuracy, cut only a few lengths at a time.

Gluing
1 Apply glue to the board in a thin line, along which the string will be stuck.
2 Place the string on to the board near the glue, and ease it along into the glue.
3 Affix the string to the board by means of pins stuck vertically through the string into the board. Secure the ends, if desired, by means of bull-clips or clothes-pegs.

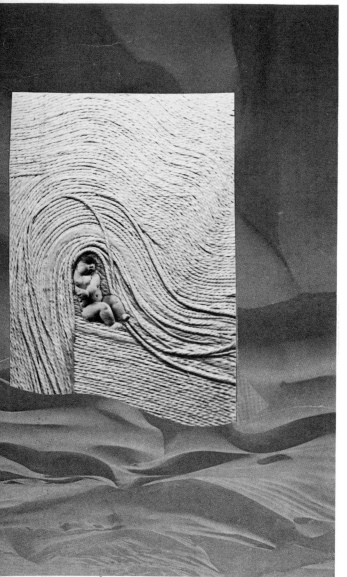

'Swinging'. Inspired by dancing of the Ballet Rambert. Batik and strings, illustrating movement of dancing couple

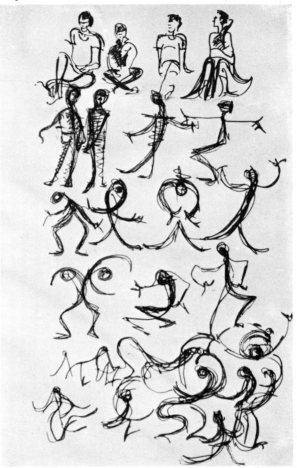

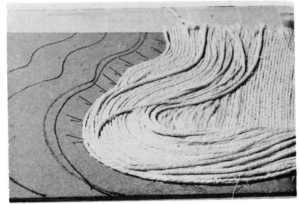

4 Continue the process by adding another line of glue adjacent to the last string and pushing the next string into it so that it touches the last string.

5 Pin this new piece to the board, removing the pins from the last row. If the string is particularly curved, however, it will still need the support.

6 Build up the collage in this way, until the area is covered with rows of curving, touching string.

7 To create a three-dimensional effect, further string is added on to the previously glued strings.

Drying

1 Remove the pins.

2 Cover the collage with paper and then heavy books to act as weights and leave to dry.

3 Trim off the overhanging pieces of string and glue on details, such as photograph in the above example.

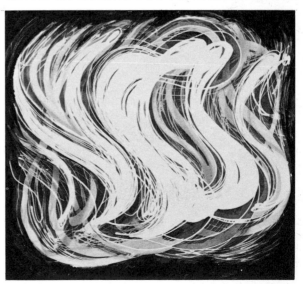

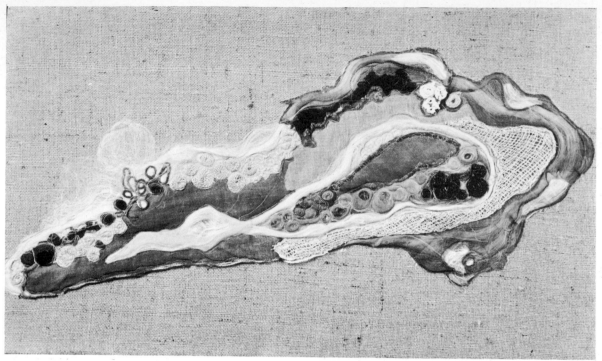

'Flint-stone' by Vivienne de la Cruz, Digby Stuart College of Education, London. Hemp covered with old nylon stockings slit to reveal the hemp in places

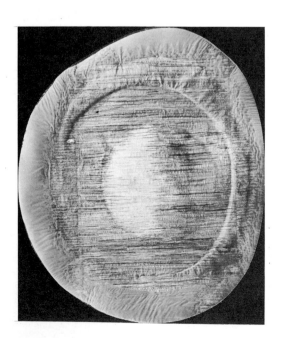

'Marble' by Sr Consolata Nowak, Digby Stuart College of Education, London. Inspired by a photograph of a marble panel in Westminster Cathedral

'Sousse'. String and fibre collage

SEED COLLAGE

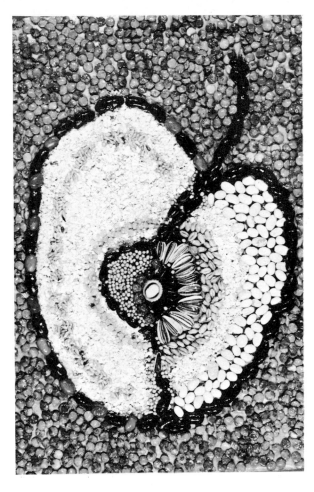

DESCRIPTION

$15\frac{1}{2} \times 15\frac{1}{2}$ in

Inspired by half an apple.

The whole collage is covered with seeds of all kinds. The inside of the apple is covered with very small seeds, the background with amber-coloured lentil seeds, the outline with dark beans and the centre dot is macaroni. The whole picture is lacquered with polyurethane clear varnish.

METHOD

Cover the base with glue, working in sections from the centre outwards. Use one kind of seed at a time and sprinkle them carefully on to the glued part. Push into place so that they touch each other.

MATERIALS

Half an apple

Firm base

Strong transparent glue and brush; solvent for cleaning brushes

Small curtain ring or macaroni for the centre

Pencil

Saucers to hold seeds

Ink and brush

Various seeds, eg white beans, oatmeal, sunflower, pepper, mustard, linseed, wheat (for the apple); split lentils (for the background); large, dark beans (for the outline)

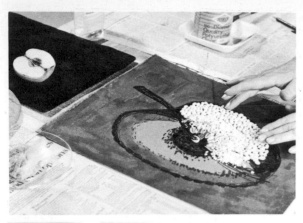

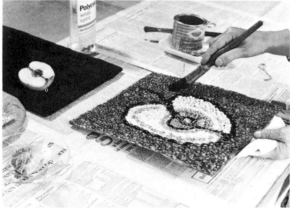

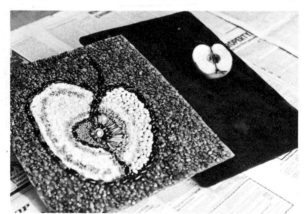

2 Apply the middle ring and the first arched row of seeds.
3 Glue a further row for seeds.
4 Apply the seeds.
5 Push the seeds together and continue with the other side.

After Covering
1 Outline with beans.
2 Fill the background with lentil seeds.
3 Leave to dry.

Varnishing
Brush the surface of the dried collage with clear polyurethane and leave to dry.
The finished collage and the original inspiration.

EXAMPLES
Photograph of human red blood cells, Textile Physics Laboratory, University of Leeds (courtesy Dr J. Sikorski)

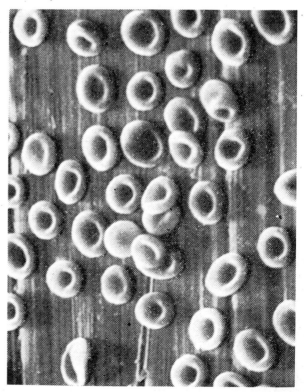

STEP-BY-STEP

The Pattern
1 Outline the circular shape, core and stem with a pencil.
2 Correct the details with ink and brush. The background may be marked in a contrasting colour or shaded with a pencil. If colour is applied, it remains visible through the space between the seeds.

The Seeds
1 Brush glue in the middle of the collage.

66

'Roman Tile' by Alison Gordon, Westminster Technical College

'Fish Mosaic' (Bardo Museum, Sousse, Tunisia)

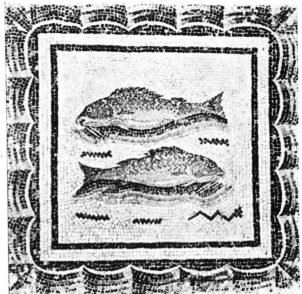

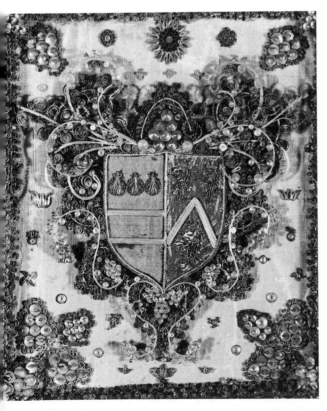

Victorian Bead Collage (Victoria & Albert Museum)

ROLLER-PRINT COLLAGES

PRINTING WITH A TWIG

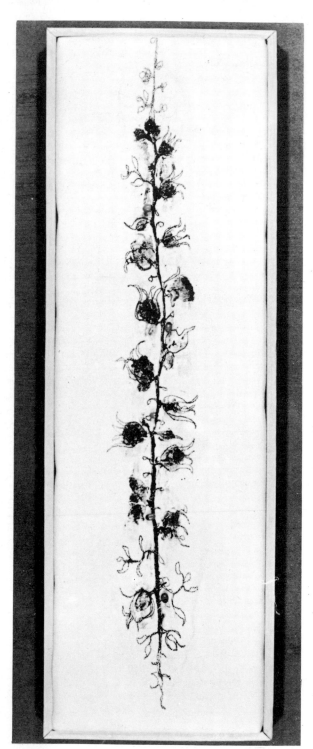

DESCRIPTION

5in × 18in

Inspired by a twig.

Black print of twig on white fabric embroidered and decorated with beads if desired.

METHOD

Apply printing ink to a twig glued on to cardboard. Then place the cardboard on to the right side of the fabric and press firmly to form a black imprint of the twig on the fabric. Embroider and decorate the print.

MATERIALS

A twig

Cardboard mount for the twig

A pane of glass with sellotaped edges for safety

Turpentine or white spirit

Newspapers

Scissors

Frame

Stapler

Beads and threads

White fabric, eg cotton or silk

Printing ink or any thick and sticky dye

Roller for printing; this may be improvised from a tin covered with thin foam

Strong glue with applicator

Gloves

Heavy books

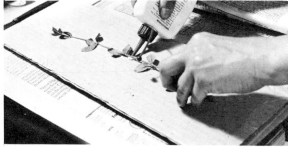

Preparation
1 Select a twig.
2 Cut cardboard to an appropriate size to serve as a mount for the twig.
3 Apply glue to the twig and place it, sticky-side down, on to the cardboard.
4 Cover the twig and cardboard with a sheet of cardboard and then with heavy books to press and dry.

Printing
1 Cut the fabric to a suitable size to be printed with the twig and to be mounted on to the frame.
2 Sellotape the fabric (right side up) to the working surface for firmness.
3 Spread ink on to the roller evenly with the help of the pane of glass. Test the even distribution of ink on a spare piece of paper.
4 Roll the inked roller over the twig.
5 Press the cardboard, with the twig face downwards, on to the fabric when the ink is still wet.
6 Lift the cardboard from the fabric and allow the print to dry.
7 Clean the roller and glass with turpentine or white spirit as soon as possible.

Mounting and Finishing
1 If desired, embroider and decorate the print with beads and/or threads.
2 Pin and staple the fabric on the frame (see page 101).

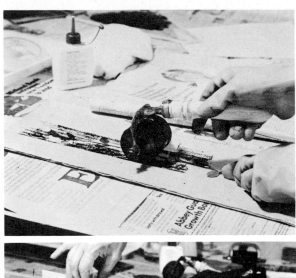

EXAMPLE
'Magnolia'. Print and silk embroidery

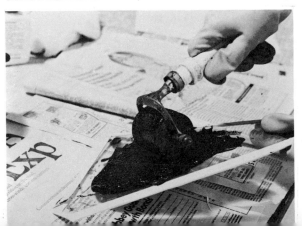

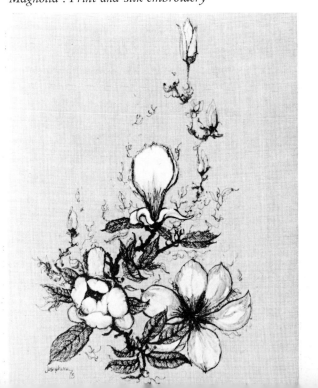

PANCAKE

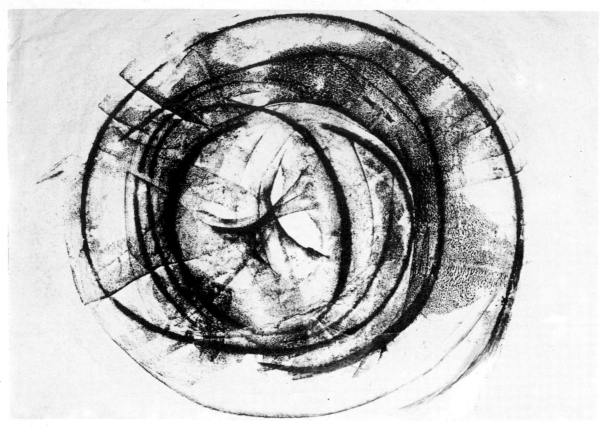

DESCRIPTION

21in × 20in

Inspired by a pancake on a plate.

Black rubbing of a coil of flex on pink and lemon background represents a pancake; the black curves emphasise the folds, the background suggests the delicate and juicy texture of the pancake.

METHOD

Colour the surface of the paper pink and lemon with wax crayons, then add the black curves by rolling an inked roller over the paper covering a coiled flex. Strings may be added to emphasise the curves.

MATERIALS

The inspiration
Coil of flex
Wooden board
Paper – strong, yet suitable for crayon-rubbing
Turpentine or white spirit
Pane of glass with sellotaped edges
Sellotape
Newspaper for covering working surface
Mount for collage
Roller; may be improvised by covering a tin with thin foam
Printing ink – any thick and sticky ink
Palette knife for spreading the ink
Wax crayons, yellow and pink
Paste and applicator
Scissors
Rag
Gloves

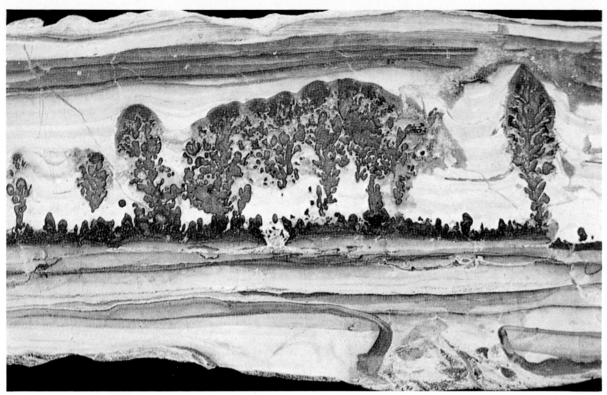

Cut-out pieces of marbled paper fitted together form a serene collage of an English landscape

'Acrylic Paint Relief'. Wet gesso strips embedded into, and sometimes covered with, thick layers of acrylic paint applied on to a papier-mâché plaque with a palette knife

'Fish Mosaic' (Bardo Museum, Sousse, Tunisia)

The Background

1 Sellotape the paper on to the wooden board to hold it secure.
2 Rub the paper with the crayons in circular movements.
3 Remove the paper from the board by carefully unsticking the sellotape.

Rubbing

1 Coil the flex flat on to the wooden board and sellotape it down to the board in several places to make it completely firm.
2 Cover the flex with the waxed paper and sellotape the paper to the board to hold it secure.

3 Ink the roller by placing ink on the pane of glass and rolling the roller over and into it.
4 Test the even distribution of the ink on the roller by running it over some spare paper.
5 Roll the inked roller over the paper, following the curves of the flex from the centre outwards.

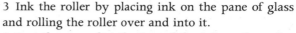

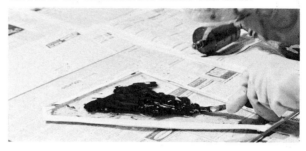

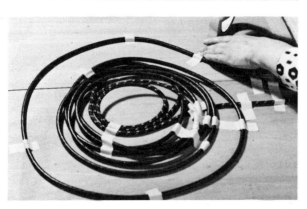

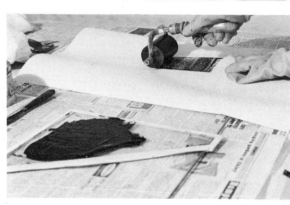

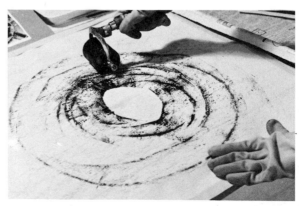

6 Clean the roller with turpentine or white spirit as soon as possible.

7 Leave the paper to dry.

8 Remove the paper from the board.

Mounting and Finishing

1 Turn the paper wrong-side up, paste it thoroughly, and glue it on to its mount.

2 Rub the surface gently with a clean rag to exclude air bubbles.

3 If the curves are not distinctive enough, glue string around the black circles to enhance the appearance.

EXAMPLES

Roller print of fruit

'Northwick Park' (1952)

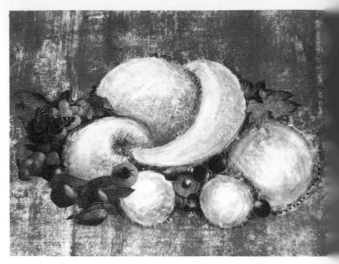

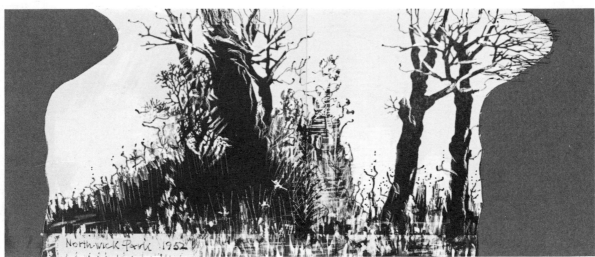

FOREST-LANDSCAPE COLLAGE

DESCRIPTION

16in × 10in

Inspired by redwood forest near Santa Cruz, California.

Black and white vertical stripes of a roller-print, accentuated by wound strands of wool, represent towering trees, with a white moon peeping through.

METHOD

Make black vertical stripes on a white background by rolling a narrow roller dipped in black ink over paper pasted on to a wooden board. Paste a white circle on to the print and then wind black and white woollen strands (approximately parallel to the stripes) round the print.

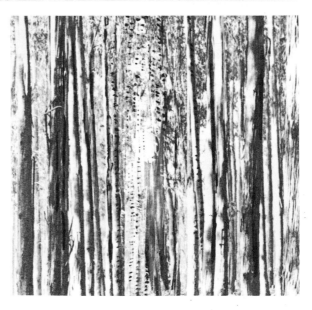

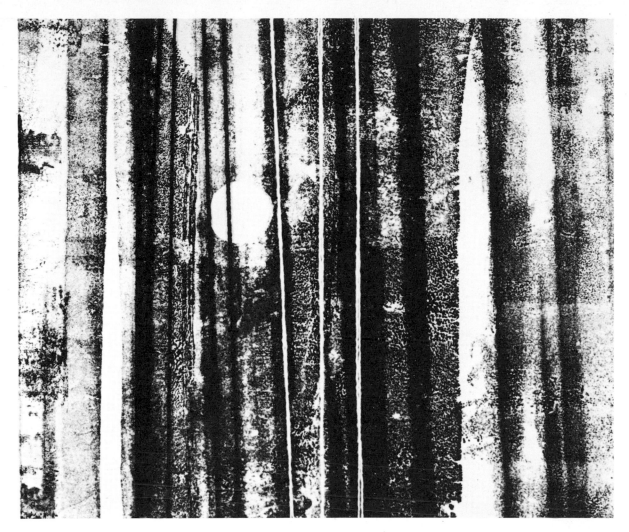

MATERIALS

The inspiration
2in roller
Printing ink – any thick
 and sticky ink
Palette knife or spreader
Turpentine or white
 spirit
White paper for the
 circle
Paste and paste brush
Sellotape

Rag
White board or a piece
 of white paper pasted
 on to a board
Pane of glass with safe
 edges
Strands of black and
 white wool
Scissors
Newspapers
Gloves

Roller Printing

1 Pour printing ink on to the pane of glass with the aid of the palette knife.

2 Dip the roller into the ink and spread evenly on the roller.

3 Experiment with the roller on newspaper, varying the pressure to see what effects may be obtained. The greater the pressure on the roller, the darker and less textured the stripe produced.

4 Replenish the ink on the roller and roll it up and down the white background with regular strokes, varying the pressure and the amount of ink on the roller. The 2in stripes overlap to form darker and varied stripes.

5 Leave the print to dry.

Cleaning the Utensils

As soon as possible after use, whilst the print is drying, clean the roller, pane of glass and palette knife with white spirit or turpentine.

Adding the Details

1 Cut out a small white circle and paste it on to the print, to represent the moon.

2 Cut strands of black and white wool to lengths either a few inches longer than the print, or a few inches longer than twice the length of the print, depending on how the threads are to be fastened to it.

3 Either sellotape one end of each thread to the underside of the print, wind it round roughly parallel to the stripes, and sellotape the other end to the underside, or wind the threads round in the appropriate places and tie tight knots at the back of the print to hold the threads in place.

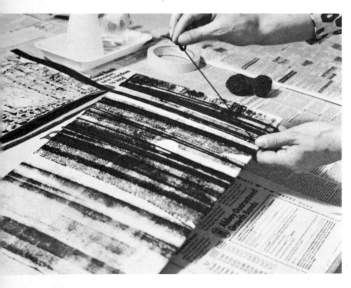

EXAMPLES

'Brighton Pier', iron structure

Photograph illustrating structure of sinews of a sea-urchin (courtesy of Textile Physics Laboratory, University of Leeds)

SCREEN-PRINTED COLLAGES
PRELIMINARY PREPARATION FOR SCREEN PRINTING

EQUIPMENT

Table or board in a well-
ventilated room to
serve as the printing
surface. Cover with
$\frac{1}{2}$in thick foam and
then with a plastic
sheet, sellotaped or
stapled to the table or
board. The fabric or
paper to be printed is
sellotaped on to this
sheet

Newspapers to cover the
working area
Drawing-pins
Stapler and staples
Sellotape
Scissors

THE PRINTING AREA

MAKING A SCREEN

When the screen is prepared it will then be either
blocked with plants or leaves; blocked with paper
pick-ups; covered with a photosensitive solution and
then exposed to the light when a pattern is placed on
it; or blocked with wax or glue.

Full step-by-step descriptions of these methods are
given on pages 81, 82, 84-6, 92.

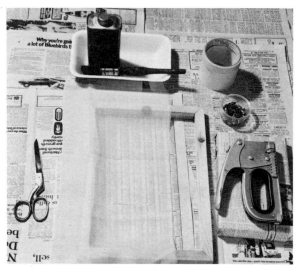

Cleaning Facilities:
Sink
White spirit or
turpentine

Rags and paper towels
or newspapers

Drying Facilities:
Either a clothes-hanger
or clothes-line with
clothes-pegs or bull-
clips; or table covered
with newspapers

Utensils:
Roller, for roller
printing; or screen
and squeegee, for
screen printing

MATERIALS
Sturdy wooden frame,
size 18in × 12in
Unpatterned organdie
(or terylene voile),
size 22in × 16in,
allowing for 2in
overlap
Shellac glue (optional)

Stapler and staples
Drawing pins
Sellotape
Masking tape, width 2in
Scissors
Books for balancing
stapler when stapling
(optional)

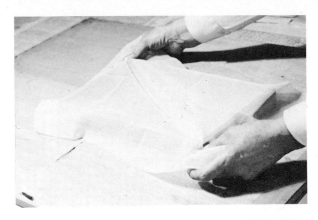

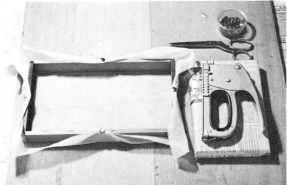

STEP-BY-STEP

Stretching the Fabric on to the Frame

1 Place the wooden frame centrally on to the fabric. Ensure the edges of the frame are parallel to the grain of the fabric and allow a 2in margin.

2 *Either* brush the right side of the frame with Shellac and then immediately place the sticky side down on to the fabric . . . *or* fold and pin the overlap on to the frame. In both cases ensure that the fabric is well-stretched and taut on the frame.

3 Staple the overlap on to the wrong side of the frame. This step is optional when Shellac is used but still adds firmness.

Masking the Fabric

Masking tape is stuck on to the screen to perform two functions:

a. To limit the size of the print – thus if the print is to be 14in × 8in, a 2in width of tape is stuck round the edge of the fabric on the frame.

b. To prevent the dye oozing out of the corners of the screen – a length of tape is placed along edge of the frame and folded over to the perpendicular edge.

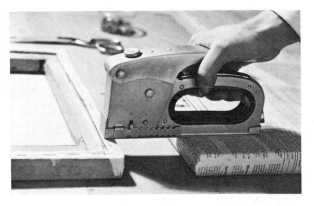

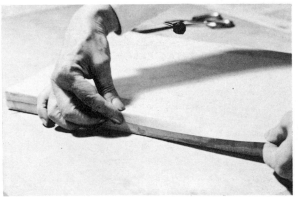

FLOWER STENCILS

DESCRIPTION

9in × 8in
Inspired by forget-me-nots and buttercups.
White silhouettes of flowers on black background.

METHOD

Arrange the dried flowers on the fabric to be printed, cover with the screen and then squeegee the dye over the frame to colour the parts of the fabric not covered with the flowers. Glue additional flowers on to the dried print.

MATERIALS

Flowers previously dried between sheets of tissue paper. Suitable flowers are simple ones with interesting silhouettes
Printing surface, padded
White spirit or turpentine
Printing table (see page 78)

A screen-printing frame covered with stretched organdie or terylene voile
Fabric or paper to be printed, 12in × 14in
Printing pigment, black
Gloves
Rags and newspapers
Glue
Squeegee

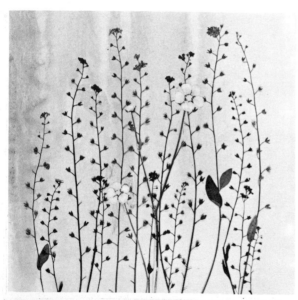

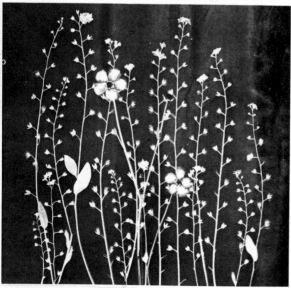

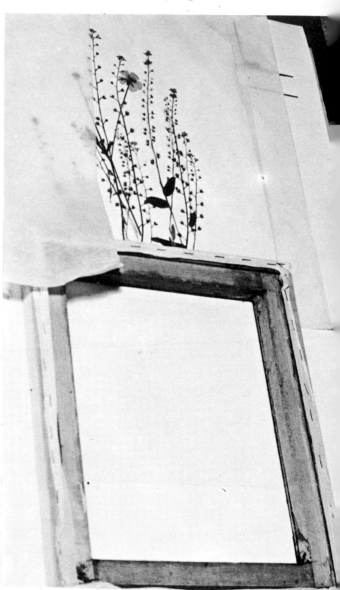

Preparing the Printing Surface

1 Sellotape the fabric to be printed centrally on to the printing surface.
2 Arrange the dried flowers on this piece of fabric.
3 Place the screen face downwards on to the arranged flowers.

Printing

1 Pour the pigment inside along one side of the frame.
2 Move the squeegee along, inside the frame. Drag the pigment with it, so that the colour is forced through on to the fabric.
3 Lift the screen and flowers off gently.

Cleaning

Clean the screen and utensils immediately with white spirit or turpentine.

Drying

Either leave the print on layers of newspaper to dry, or hang it from a clothes-line with clothes-pegs or bull-clips to dry.

Finishing

Glue additional dried flowers on to the print.

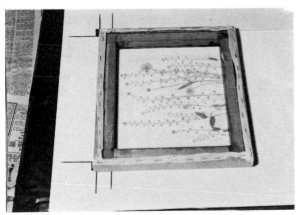

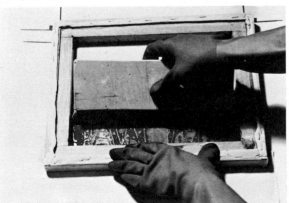

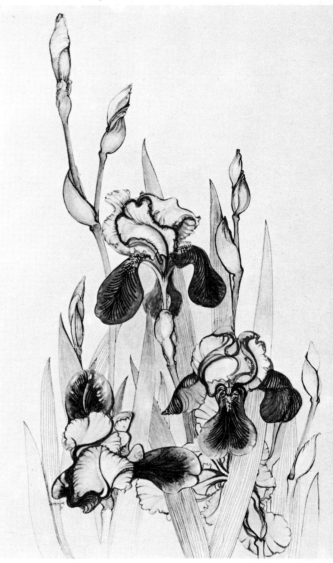

PAPER PICK-UP

DESCRIPTION

9in × 8in

Inspired by motion of animated creatures, such as coiling of a viper.

Pattern formed by superimposition of wavy motif in varying positions on to the background.

METHOD

Cut out the same shape in triplicate, and use two of the pieces to form a stencil print. Stick the third piece on to the print to complete the collage.

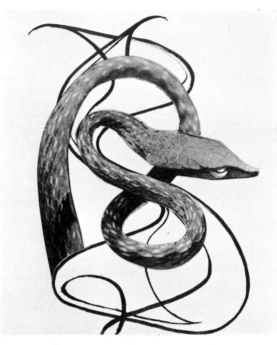

MATERIALS

Shape cut from paper of a contrasting colour to the printing pigment to be used

Two similar shapes of any colour

Squeegee

Turpentine or white spirit

Rag

Printing screen covered with organdie or terylene voile

Printing surface (see page 78)

Sellotape

Fabric or paper to be printed

Printing pigment

Newspapers

Gloves

STEP-BY-STEP

Preparation

1 Sellotape the fabric to be printed centrally on to the printing surface.

2 Arrange two of the shapes on to the fabric.

3 Place the printing screen, face downwards, on to these shapes.

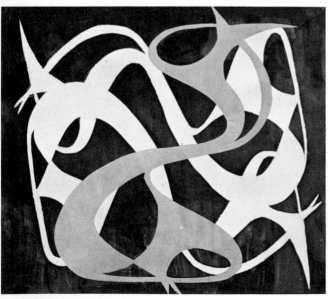

Printing

1 Pour the pigment inside, along one side of the frame.

2 Move the squeegee along the length of the screen, taking the pigment with it.

3 Lift the screen, which will now have the paper pick-ups stuck to it.

4 Continue to print with this screen on to blank pieces of fabric.

Cleaning

Clean the screen and utensils immediately with white spirit or turpentine.

Drying

Either leave the prints to dry flat on newspapers or hang them from a clothes-line.

Finishing

Stick the third paper shape, of colour contrasting with the dye, on to the dry print.

EXAMPLE
'Crouching Poppy'

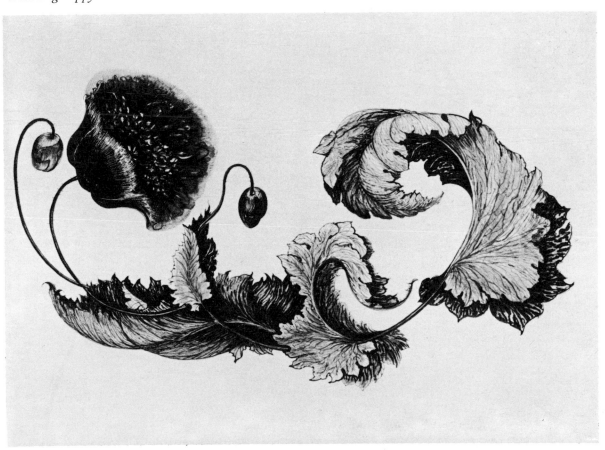

DESCRIPTION

Inspired by metal fracture. Photograph from Textile Physics Laboratory, University of Leeds.

METHOD

The printed zig-zag background is decorated with a glued, blue zig-zag shape. The screen obtained has the zig-zag unblocked.

MATERIALS

Coating the Screen:

Frame covered with organdie or terylene voile

Gloves

Geometrical square or ruler for spreading the solution over the screen

Photosensitive solution – either 'Green Photosensitive Screen Filler'; or home-made solution (to be used within 24 hours) of $\frac{1}{2}$pt warm water, 1oz (2 dessertspoons) of gelatine, $\frac{1}{4}$oz (1 heaped teaspoon) of potassium dichromate.

Drying the Coated Screen:

A dark cupboard to store the frame

The home-made solution is colourless, making the previously coated areas difficult to see. The commercial variety is Green and so preferable. Note that the solution is photo-sensitive and so must not be exposed to the light.

Four empty jam-jars of equal height to support the drying screen

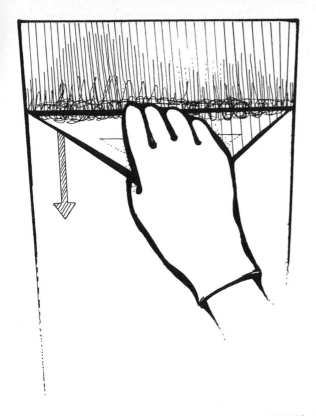

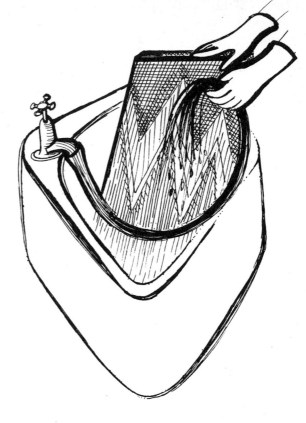

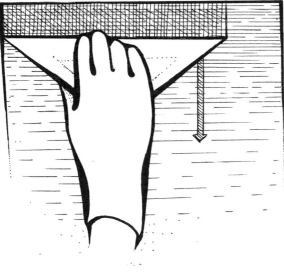

The Exposure:
300 watt light-bulb (or
 bright sunlight)
Clock
Pane of glass
Weights, if screen is
 large
A pad to be placed
 underneath the screen
 to block out all light
 during exposure. This
 may be made from a
board or book covered
with foam, a black
cloth or a blanket
Sheet of transparent
 tracing-paper of
 frosted acetate, with
 the motif drawn or
 painted on it. A
 photographic negative
 may be used in place
 of the tracing paper

Washing
Sink or bath to rinse the
 screen after exposure

STEP-BY-STEP

Coating
1 Using gloves and under the safe red or yellow light,
coat the screen with photosensitive solution. The
commercial variety may be used straight from the
container but the home-made kind must be blood-
warm.

2 Using a ruler or square, spread the solution over the screen, first widthwise and then lengthwise.

3 Place the coated screen, face upwards, on to the four jam-jars which support the corners, and put in a dark cupboard to dry.

Exposure

1 Make a dark pad by covering a book with dark cloth to such a size that it will fit snugly under the screen and block out all light from underneath. Place this tightly under the screen in the cupboard.

2 Place the transparent sheet with the final pattern on it on to the top of the screen and cover with a pane of glass. If the screen is large, weights may be required to hold the glass in place. These operations should still be carried out in the dark cupboard.

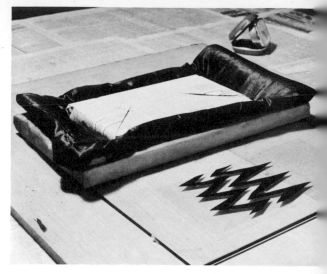

3 Remove the screen from the cupboard and expose the top side to *either* sunlight for 2hrs . . .

. . . *or* a 300 watt light for 5–6mins.

4 After exposure, quickly remove the glass and the negative.

Washing

1 Without delay, after the removal of the negative, rinse the screen gently in a bath of cold water.

2 Plunge the screen gently into a bath of warm water to dissolve the unsensitised parts of the solution on the screen.

The exposed parts of the coated screen become hard and opaque as the solution adheres to them. The unexposed areas are unsensitised and so the solution washes out easily to leave a screen with a pattern corresponding to the drawn or painted negative.

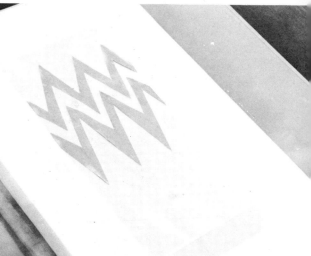

Drying

Simply leave the screen to dry.

Checking the Screen

Hold the screen to the light and see if there are any 'pin-holes' formed by air-bubbles, in the sensitised parts. If so, add more photosensitised solution to close them.

Printed pattern with the screen

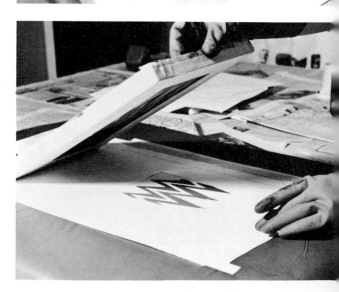

SILVER BIRCH

DESCRIPTION

24in × 60in

Inspired by paint peeling from a door.

Large, long, black and white collage comprises repeating background print decorated with black net, embroidery threads, and strings to resemble trunk of silver birch tree.

METHOD

Prepare an acetate transparency from a sketch of peeling paint and use this to print a single module. For the actual collage four repeats of the module were printed and the resulting length decorated with net and threads.

Photosensitised screen
 (see pages 84-5
 for preparation
 instructions)

The final screen with
 discarded
 transparency

Printing:

Fabric or paper to be
 printed, size 20in ×
 26in

Printing surface (see
 page 78), size 40in ×
 40in approx.

Pigment solvents, eg
 white spirit or
 turpentine

Photosensitised screen
 with the required
 pattern on it, size
 19in × 14in

Squeegee
Screen-printing pigment
Gloves
Newspapers and rags
Strip of wood on which
 to balance the frame
 between prints
An assistant may be
 necessary to hold the
 frame in place whilst
 printing if the frame
 is large

Drying:

A clothes-line

Pegs

Finishing off

Black net

Various black and white
 strings, cottons and
 embroidery threads

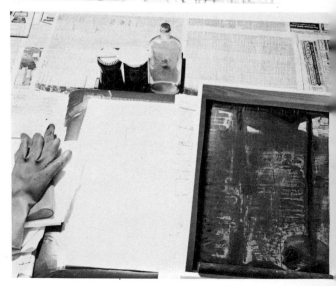

Preparing a Photosensitised Screen

Use the method on pages 84-5. Sketch the peeling door (using dense black ink or paint) on to the acetate transparency. To facilitate the inconspicuous joining of successive prints, the piece of acetate transparency should be slashed through the most densely coloured parts as follows.

The straight edges are then sellotaped together thus. Therefore on subsequent printing, the successive prints will fit together neatly like a jigsaw puzzle.

Printing with the Screen

1 Sellotape the fabric to be printed on to the printing surface.

2 If required, outline the screen on the plastic sheeting to form guidelines.

3 Place the screen on to the fabric, inside the marked frame.

4 Pour the pigment evenly along the top edge of the screen. (*Continued over page*).

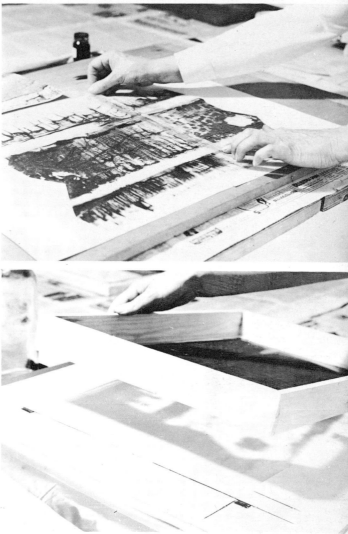

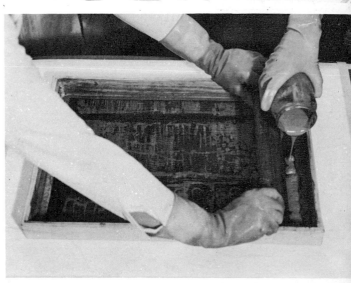

5 Drag the pigment along the length of the screen with the squeegee with one hand whilst holding the frame firmly with the other. If the screen is large (as illustrated) assistance may be necessary.

6 Lift the screen carefully from the fabric and rest one edge of it on a block of wood and the opposite edge (the edge holding the pigment) on the level surface so that the screen is tilted.

7 The final print.

Cleaning
As soon as the printing process is complete, clean the screen thoroughly with white spirit or turpentine.

Drying
Hang the length of print on a clothes-line with pegs for it to dry thoroughly.

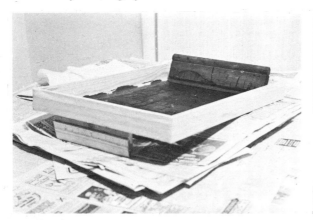

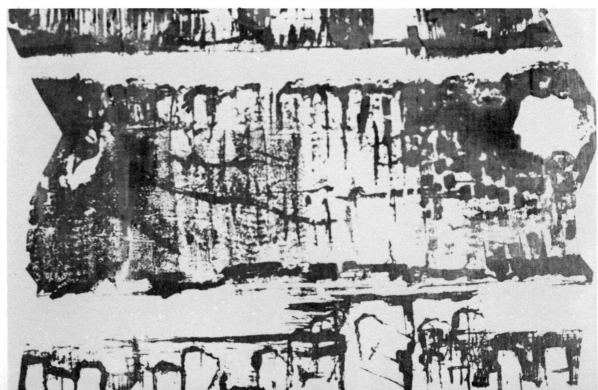

WAX-BLOCKED PRINTING SCREEN

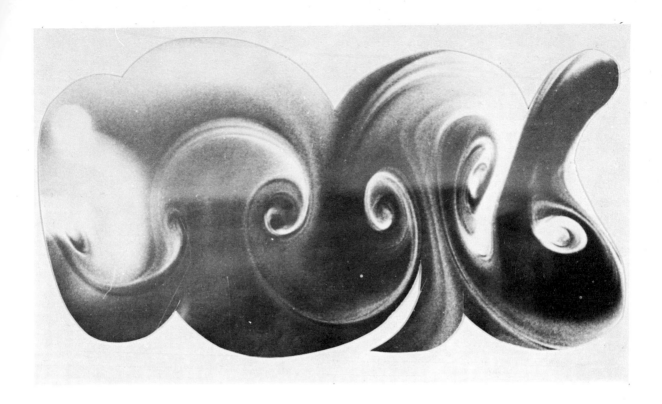

DESCRIPTION

8in × 10in

Inspired by a pattern of wind vortex made by a vibrating cable.

The print is a simplified line drawing of air-thrust of the supersonic jet, Concorde.

METHOD

Draw the required pattern on to the printing screen with molten wax. When dry, brush the whole screen with photosensitive solution, which, on exposure to light, adheres to the parts of the screen not 'masked' with wax. Scrape off the wax from the pattern on the screen. The pattern is clear and transparent whilst the background is sealed with photosensitised solution.

MATERIALS

Sketch of the inspiration on paper the size of the final print

Wax applicator – *either* a hard brush *or* a 'tjanting' (illustrated below)

Printing screen (a frame covered with organdie or terylene voile)

Photosensitive solution (see page 84), or resin-based glue or any substance which hardens on exposure to air and does not melt like wax

Iron

Spatula

Coloured pencil, crayon or chalk

Appliance (eg electric ring hot plate) to heat the wax and keep it warm

Saucepan(s) in which to place wax. Small saucepan with wax inside may be placed in larger saucepan filled with hot water. When water boils, wax is ready for use. Note that wax is inflammable and should not be heated over direct flame.

Brush

Newspapers and blotting paper

Ironing-board covered with newspaper

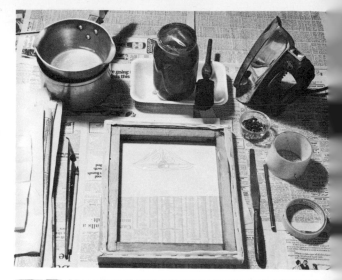

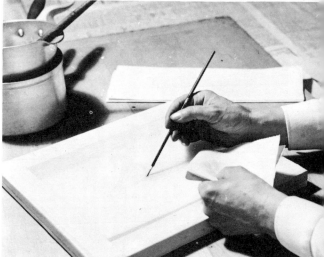

STEP–BY–STEP

Blocking the Screen

1 Place sketch of the inspiration underneath the printing screen so that it shows through the translucent screen.

2 Trace the motif on to the screen with a coloured pencil as a guideline for the wax application.

3 Heat the wax gently until it melts, at the same time warming the wax applicator by leaving it in the wax. Keep the wax molten (about 90°C).

4 Apply the wax along the coloured-pencil marks on the screen with the applicator either by brush . . . or by tjanting – an implement used to apply wax in batiking.

The wax cools quickly when in contact with the cool air and so the applicator should be re-warmed and replenished with molten wax frequently to ensure proper adhesion of the wax on to the screen.

5 Leave the wax to dry.

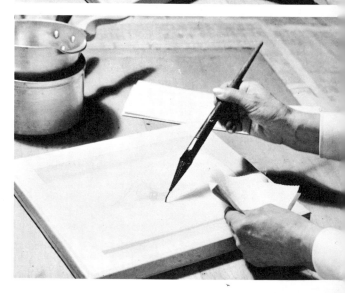

Applying the Photosensitive Solution

1 Brush the whole screen with the solution, carefully covering the whole area (it will not penetrate the waxed pattern). Leave it to harden in the light. If a resin-based glue is used, or any similar substance, it is similarly applied to the screen and left to harden.

2 Hold the screen against the light to detect any 'pin-holes' or air-bubble spaces left in the hardened solution. These are retouched with more solution and left to harden.

Removing the Wax

1 Remove the bulk of the wax gently by scraping it off with a spatula. Whilst scraping, support the organdie underneath with the other hand to prevent damage to the screen.

2 Remove the rest of the wax between the fibres by sandwiching the organdie between sheets of blotting paper and pressing the 'sandwich' with an iron. The heat of the iron melts the wax, which is absorbed by the blotting paper.

3 Repeat the ironing between fresh paper until no more wax is left – the parts of the organdie which were covered with the wax become translucent again and readily penetrable by pigment.

Printing

Print with the screen (see page 89).

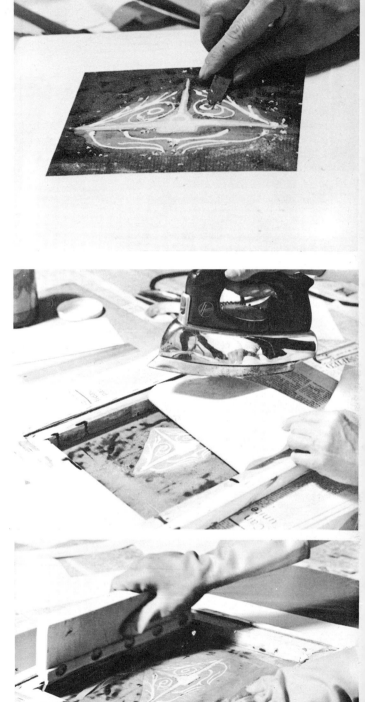

93

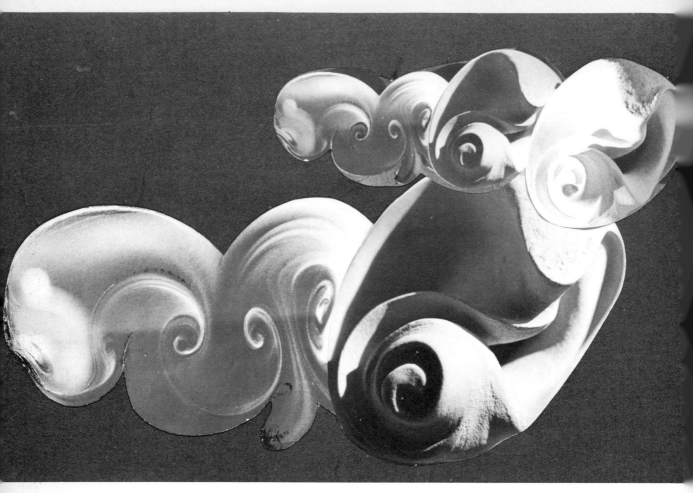

EXAMPLES

'Vortex'. *Photomontage from photographs of ceramic sculpture and wind vortex*

Ceramic sculpture

'Peony'

FUSIBLE PROCESSES IN COLLAGE

EGG COLLAGE

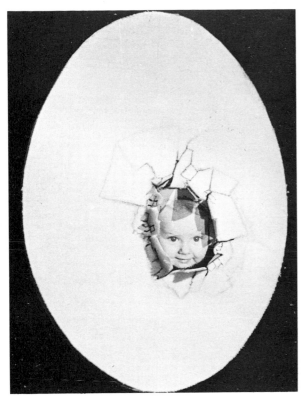

(USING A SLIDE PROJECTOR)

DESCRIPTION
10in × 14in
Inspired by the hatching of a chick.
Baby's face peeps from an outsize 'cracked' egg mounted on dark brown felt.

METHOD
Make a sketch of the inspiration, drawing directly from a slide of it projected on to a screen. Mount the cut-out sketch on a piece of fabric, fusible on one side, and clip and fold to form a peep-hole. Mount the white egg on to the felt background by means of a piece of paper fusible on both sides ('mounting paper').

MATERIALS
Slide of the inspiration
Slide-projector and
 screen
Small photograph of a
 baby's face
Background board
 covered with dark-
 brown felt
Iron and ironing-board
Scrap paper
Sellotape
White paper

Felt pen of a dark colour
Small piece of white
 fabric with one side
 fusible on ironing, eg
 Stayflex, Vilene or
 Solena, size 6in × 7in
Scissors
Small piece of mounting
 paper fusible on both
 sides on ironing, size
 6in × 7in

STEP-BY-STEP
Sketching
1 Set up the projector with the slide of the inspiration on it; erect the screen.

2 Sellotape a piece of white paper, larger than the image of the slide, on to the screen so that the inspiration is directly on it.

3 Outline the image on to the paper with a felt marker, paying attention to the lines and shadows formed at the cavity.

4 Compare the image with the sketch.

Fusing and Cutting Out the Egg

1 Lay on the ironing board the Stayflex, fusible side up; then the sketch, face downwards; then a piece of scrap paper.

2 Press the 'sandwich' with a heated iron so that the Stayflex is mounted on to the sketch. The piece of paper prevents the Stayflex sticking to the iron and prevents the sketch being singed.

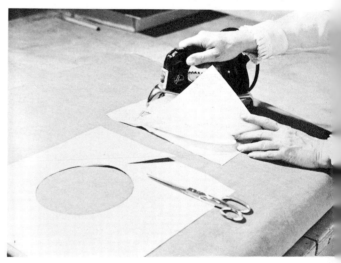

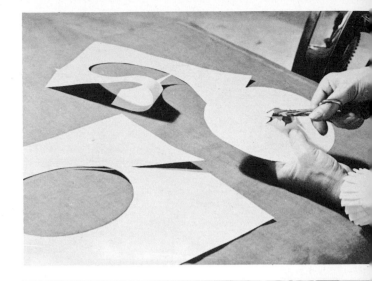

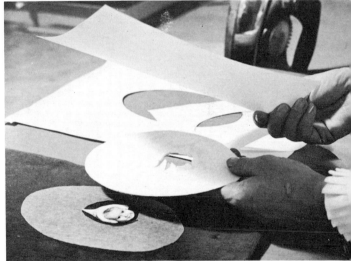

3 Cut out the shape of the egg, around the lines of the sketch which show faintly through the Stayflex.
4 Cut out the hole in the egg by slitting along the lines of the sketch near the cavity and folding back the pieces of mounted Stayflex. The other lines of the sketch, further away from the cavity, show faintly through and appear as small cracks in the shell.

Mounting the Egg
1 Cut out a piece of the mounting paper to the same shape as the egg.
2 Place the mounting-paper shape on the felt, in the position the egg is to take.
3 Place the photograph on the mounting paper so that it will peep through the hole in the egg.
4 Place the egg on the mounting paper and adjust all three so that the mounting paper is directly below the egg and not showing around the edges; ensure that the face peeps through neatly.
5 Cover the 'sandwich' with clean paper and press gently with a warm iron so that the mounting paper sticks to the felt, the photograph, and the egg.
6 Leave the mounted collage to cool.

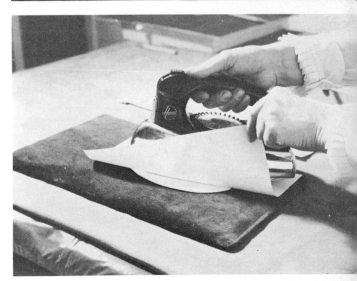

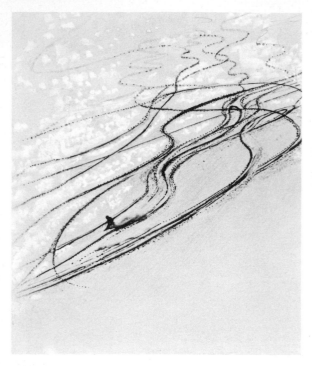

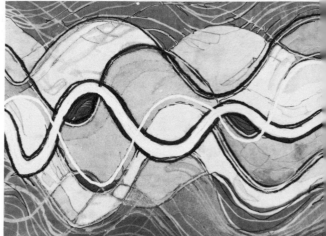

Adhesive
Sewing machine
Scissors
Stapler for stapling
 completed collage to
 the frame

4 sheets of plain, thin
 paper; tissue paper
Pencil or pen
Pins
Iron and ironing-board

DESCRIPTION
23in × 19in
Inspired by sound vibration during skiing.
Pattern is predominantly purple, with bold orange,
yellow and white wavy design.

METHOD
Decide on a motif and sketch it on to paper. Then
make paper patterns in the shape of each coloured
section of the collage. Cut out the pieces from the
coloured materials and 'fit together' on a fabric of
which one side is fusible on ironing. Iron the whole
composition on to the fusible fabric to mount it, and
decorate with net and threads before framing.

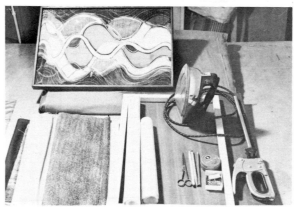

MATERIALS
Fabric – the predominant
 colour (in this case,
 purple batik);
 oddments of plain
 fabrics in yellow,
 orange, white; net or
 organdie to add
 variety to the tones
Frame

Fabric fusible on one
 side, eg interlining
 such as Stayflex,
 Vilene or Super-Dot-
 Solena Strings and
 threads for decora-
 tion, and basting the
 pieces together
 (optional)

STEP-BY-STEP

Tracing the Pattern
1 Decide on the motif.
2 Take one sheet of the thin paper, sketch the wavy
lines on it and mark the sections with their intended
colours.
3 Place this blueprint on to the other three sheets of
paper and pin the corners together to keep the papers
from slipping.
4 Transfer the wavy motif through to the other sheets
by sewing along the lines with an unthreaded sewing
machine, thus forming perforations through all four

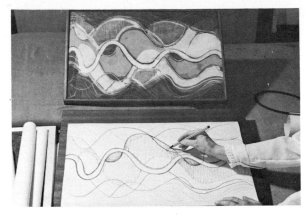

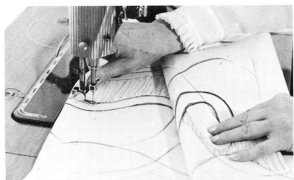

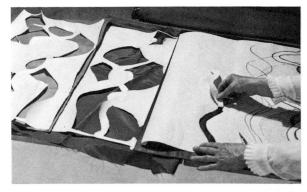

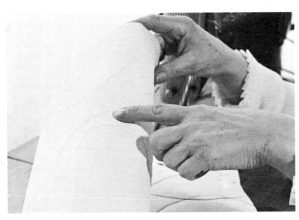

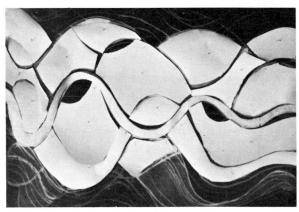

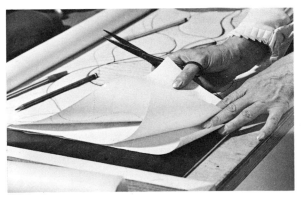

sheets. Alternatively the tracing may be done by hand.

5 Allot one sheet of paper to each coloured fabric, and mark the pieces to be that colour on each sheet, from the blueprint.

6 Pull out the pieces to form paper patterns.

7 Put the pieces together to check the patterns.

8 Use these patterns to cut out pieces of the right shape from the coloured fabrics.

Assembling

1 Spread out the fusible fabric and cut out an oblong the same size as the blueprint.

2 Use this as the base, fusible side uppermost, and fit the coloured sections together on it like a jigsaw puzzle – finishing with the largest piece of predominant fabric.

3 Secure the whole composition together by means of pins or threads.

Mounting on to Fusible Fabric

1 Cover the whole composition with a piece of tissue paper.

2 Remove the pins or threads without disrupting the 'jigsaw'.

3 With a warm iron, gently press the 'sandwich' over the tissue. Through the translucent tissue, the progress of the fusion may be followed and the creases smoothed out before fusion.

4 Leave the collage to cool.

Decoration and Framing

1 Sew and glue net and threads on to the collage to vary the tones and enhance the pattern.

2 Frame the collage (see page 101).

EXAMPLES

'Frou-frou'. *Experimental collages in polymer and acetate made by author, using equipment and material in the Department of Textile Industries, University of Leeds (Courtesy of Dr G. East)*

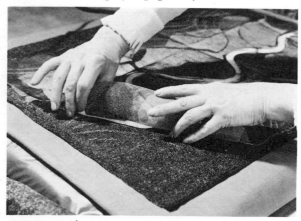

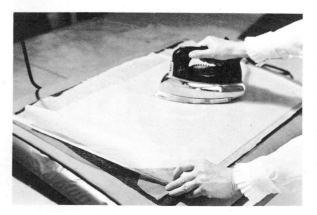

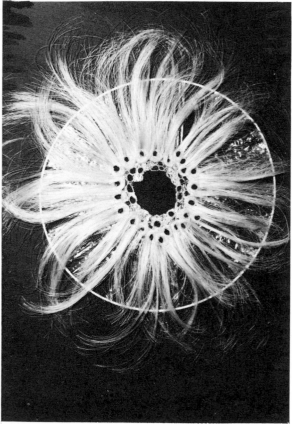

MOUNTING FABRIC COLLAGE

15in × 19in

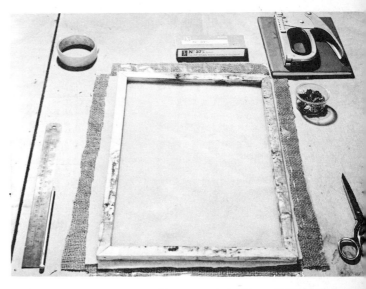

MATERIALS

Frame, size 15in × 19in
Fabric, size 20in × 23in
(allow at least 5in for
overlap)
Thin foam or wadding
($\frac{1}{4}$in thick), size 17in
× 21in
Scissors

Drawing-pins
Stapler and staples
Ruler
Pencil
Sellotape
Books or periodicals to
balance stapler whilst
stapling

STEP-BY-STEP

Preparation

1 Place the fabric right side down on to the table
followed by a smaller oblong of foam, and then the
frame on top of both.
2 Mark a margin of $2\frac{1}{2}$in along the edges, fold margin.
There will be a surplus bulge of material in corners.
Cut along the margin and again trim off the corners.
3 Sellotape the edges of the fabric to prevent fraying.
4 Leave about $1\frac{3}{8}$in to cover the edge of the frame
along the sides, and fold the sellotaped edges as
shown.
5 Pin the folded edges of the fabric to the frame with
drawing-pins, ensuring that the fabric is stretched
parallel to the frame along the warp and the weft and
not along the bias.
6 Pin the corners neatly so that the raw edges are
tucked under.

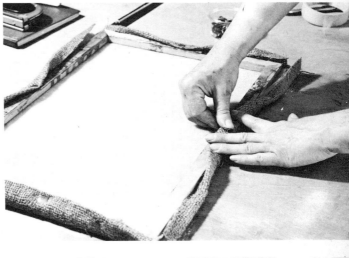

Stapling

1 Place books under the stapler to the height of the
frame and staple the fabric to the frame between the
drawing-pins.
2 Remove the drawing-pins and staple again in the
vacant spaces.
3 Make the corners neat and staple firmly along the
fold.

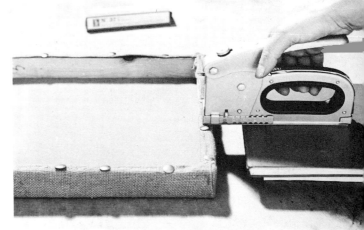

FURTHER READING

Anderson, Mildred. *Original Creations with Papier-mâché* (1967)

Ash, Beryl and Dyson, Anthony. *Introducing Dyeing and Printing* (1970)

Bedford, Betts. *Exploring Papier-mâché* (1955)

Bodor, John. *Rubbings and Textures* (1968)

Burggrat, Manfred. *Fun with Coloured Foil* (1968)

Butler, Anne and Green, David. *Pattern and Embroidery* (1968)

Carter, Jean. *Creative Play with Fabric and Thread* (London and New York, 1968)

Connor, Margaret. *Introducing Fabric Collage* (New York, 1969)

Conran, Terence. *Printed Textile Design* (1957)

Daniels, Harvey. *Printmaking* (1971)

Dean, Beryl. *Creative Appliqué* (1970)

Di Valentin, Maria and Louis. *Practical Encyclopedia of Crafts* (New York, 1970)

Green, Peter. *Creative Print Making* (1964)

Haffer, Virna. *Making Photograms* (1969)

Haley, Ivy. *Creative Collage* (1971)

Hewitt-Bates, J. S and Halliday, J. *Three Methods of Marbling.* Dryad leaflet no. 74 (1930)

Hobson, June. *Dyed and Printed Fabrics* (1965)

Honeywood, Mary. *Making Pictures in Paper and Fabric* (1969)

Horn, George F. *Posters* (1964)

Howard, Constance. *Inspiration for Embroidery* (1970)

Hutton, Helen. *The Technique of Collage* (1968)

Kampmann, Lothar. *Picture Printing* (1968) *Pictures with Inks* (1970) *Pictures with Paints* (1968)

Kenny, Carla and John. *The Art of Papier-mâché* (1969)

Kinsey, Anthony. *Introducing Screen Printing* (1967)

Kuykendall, Karen. *Art and Design in Papier-mâché* (1968)

Laye, Andrew. *Creative Rubbings* (1967)

Lorriman, Betty. *Creative Papier-mâché* (1971)

Meilach, Dona. *Collage and Found Art* (1965)

Mills, Vernon. *Making Posters* (1967)

Monk, Kathleen. *Fun with Fabric Printing* (1969)

Nutall, Prudence. *Picture Framing for Beginners* (1968)

Parker-Johnson, Meda and Kaufman, Glen. *Design on Fabrics* (1967)

Pelzold, Paul. *Effects and Experiments in Photography* (1973)

Reid-Boylston, Elsie. *Creative Expression with Crayons* (1954)

Rothenstein, Michael. *Relief Printing* (1970)

Rottger, Ernst, Klonte, Dieter and Saltzmann, Friedrich. *Surfaces in Creative Design* (1970)

Russ, Stephen. *Fabric Printing by Hand* (1964)

Searle, Valerie and Alan, Rob. *Screen Printing on Fabric* (1968)

Seyd, Mary. *Designing with String* (1967)

Simms, Caryl and Gordon. *Introducing Seed Collage* (1971)

Stevens, Harold. *Design in Photo Collage* (1967)

Taubes, Frederic. *Better Frames for Your Pictures* (1968)

LIST OF SUPPLIERS

GREAT BRITAIN

ADHESIVES

Pastes

Paper to paper adhesives – Gloy and Gripfix, from stationers

Polycell, from J. Lines, Tottenham Court Road, London W1, and Do-It-Yourself suppliers

Glues

For sticking wood, paper, fabric to fabric – Copydex, from Copydex Ltd, 1 Torquay Street, London W2, and stationers

For sticking most materials to fabric – Marvin Medium, from Margros Ltd, Monument Way, West Woking, Surrey

All-purpose glues – Bostik, Dufix, Sellobond, UHU, from hardware stores

Strong glues for sticking metal, wood and heavy objects – Bondcrete, Polybond, Richafix, Unibond, from most builders' merchants

PAPER AND CARDBOARD

E. Arnold & Sons Ltd, Butterley Street, Leeds 10

Dryad Ltd, Northgates, Leicester LE1 4QR

F. G. Kettle (for coloured and tissue paper), 127 High Holborn, London WC1

Paper Chase (for coloured and tissue paper), Tottenham Court Road, London W1

Reeves & Sons Ltd, Lincoln Street, Enfield, Middlesex

Rowney & Co Ltd, 10 Percy Street, London W1, and from stationers and artists' suppliers

WOOD, HARDWOOD AND PLYWOOD

From Do-It-Yourself stores and timber yards

ROPE AND STRING

Russell and Chapple, Monmouth Street, London WC2

Builders' merchants (especially for plumbers' hemp), yacht chandlers, ironmongers

EMBROIDERY THREADS

Dryad Ltd, Northgates, Leicester LE1 4QR

The Needlewoman, 146–8 Regent Street, London W1R 6BA

Toye, Kenning & Spencer Ltd (for metal threads), Regalia House, Red Lion Square, London WC1, and haberdashers

BEADS

Eles & Farrier Ltd, 5 Princes Street, Hanover Square, London W1, and haberdashers

GENERAL PHOTOGRAPHIC

Kodak Ltd, 246 High Holborn, London WC1

SCREEN-PRINTING

Davis (Patents) Ltd, 18 Phipp Street, London EC2

T. N. Lawrence and Son Ltd, 2 Bleeding Heart Yard, Greville Street, London EC1

Screen Process Supplies Ltd, 24 Parson's Green Lane, London SW6

Selectasine Silk Screens Ltd, 22 Bulstrode Street, London W1

SCREEN-PRINTING DYES

Geigy (UK) Ltd (for Tinolite), 42 Berkeley Square, London W1, and Simonsway, Manchester 22

Mayborn Products Ltd (for Procion), 139–47 Sydenham Road, London SE26

Skilbeck Bros Ltd (for Helizarin), 55–7 Glengall Road, London SE15

GENERAL CRAFT

Crafts Unlimited, 21 Macklin Street, Covent Garden, London WC2

Craftsmen's Distributors Ltd, 1597 London Road, London SW16

Dryad Ltd, Northgates, Leicester LE1 4QR

The above list is necessarily restricted and may be supplemented by reference to the 'yellow pages' of local telephone directories.

AMERICA

ADHESIVES

Pastes

The American Crayon Co, 1076 Hayes Avenue, Sandusky, Ohio 44870

Milton Bradley Co, 74 Park Street, Springfield, Massachusetts, and any stationers

Glues

Ceramichrome Inc, 12905 South Spring Street, Los Angeles, California

Utrecht Linens Inc, 33 35th Street, Brooklyn, New York, and hardware stores

PAPER AND CARDBOARD

CCM Arts and Crafts Inc, 9520 Baltimore Avenue, College Park, Maryland 20740

Dick Blick Co, PO Box 1267, Galesburg, Illinois

Vanguard Crafts, Inc, 2915 Avenue J, Brooklyn, New York, and stationers and artists' suppliers

WOOD, HARDWOOD AND PLYWOOD

Do-It-Yourself stores and lumber yards

ROPE AND STRING

Marine equipment stores, hardware stores, garden stores

EMBROIDERY THREADS

Artisans Guild Inc, Box 42, Cambridge, Massachusetts

Creative Hands Co, Inc, 4146 Library Road, Pittsburgh, Pennsylvania, and haberdashers

BEADS

CCM Arts and Crafts Inc, 9520 Baltimore Avenue, College Park, Maryland 20740

The Craftool Company, 1 Industrial Road, Wood-Ridge, New Jersey 07075

GENERAL PHOTOGRAPHIC

Eastman Kodak Company, Rochester, New York 14650

SCREEN-PRINTING

Chicago Screen Supply, 882 Milwaukee Avenue, Chicago, Illinois

Graphic Arts Center, 1534 West 7th Street, Los Angeles, California

Standard Screen Supply Corp, 54 West 21st Street, New York

SCREEN-PRINTING DYES

American Crayon Co (for Acco-Lite), Sandusky, Ohio

Chemical Manufacturing Co (for Procion), Madison Avenue, New York

GENERAL CRAFT

American Handicrafts, PO Box 791, Fort Worth, Texas 76101

CCM Arts and Crafts Inc, 9520 Baltimore Avenue, College Park, Maryland 20740

For a comprehensive list of suppliers, the magazine *School Arts* prints a yearly list